WHITSTABLE

THROUGH TIME

Kerry Mayo

AMBERLEY PUBLISHING

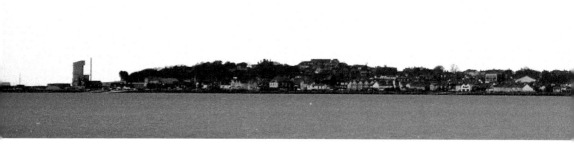

To Tony, whose support never wavers

With thanks to Brian Hadler for your knowledge, research and time

First published 2014

Amberley Publishing
The Hill, Stroud, Gloucestershire, GL5 4EP
www.amberley-books.com

Copyright © Kerry Mayo, 2014

The right of Kerry Mayo to be identified as the Author
of this work has been asserted in accordance with the
Copyrights, Designs and Patents Act 1988.

ISBN 978 1 4456 3292 6 (print)
ISBN 978 1 4456 3301 5 (ebook)

British Library Cataloguing in Publication Data.
A catalogue record for this book is available from the
British Library.

Typesetting by Amberley Publishing.
Printed in Great Britain.

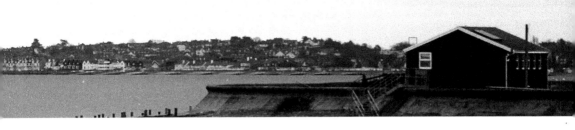

Introduction

Stand on Whitstable's pebbly beach by the Horsebridge jetty and be surrounded by panoramic views, history and culture.

To the west is the ancient settlement of Seasalter, listed in the Domesday Book of 1086 as belonging 'to the kitchen of the Archbishop' of Canterbury, and where thirteenth-century salt works were found. Today, local produce graces the tables at a Michelin-starred gastropub at this far end of town.

Offshore to the north lie the oyster beds, whose harvests have nourished invaders, locals and visitors for millennia, and where the smacks once dredged 80 million oysters a year. Each summer, the Oyster Festival celebrates the bounty of the sea, drawing thousands of people to the town. Helmet diving originated from these shores; men from Whitstable risked their lives in weighted suits to drop 100 feet into murky waters in search of rich rewards from wrecks below. Smuggling was rife, with many locals involved: collecting bags from drop sites offshore at night, digging tunnels between the cellars of buildings, or standing lookout for raids by Customs men.

To the east lies the harbour, once the home of 300 sailing vessels, many made in Whitstable boatyards, and a daily port of call for colliers from the North East. After 1830, the coal was loaded onto the trains of the Canterbury & Whitstable Railway for transportation onwards. The 'Crab and Winkle' line, as it was known, opened as the first passenger and freight railway service in the world and is now a scenic cycling path. Today, the harbour, overlooked by Whitstable Castle, is dominated by local fishing vessels and people flock to its fish market, eateries and artisan huts.

Finally, to the south lies the town itself, the scene of much hardship over the years, including flooding, fire and wartime bombings. Now, it

is vivacious and animated, with a quirky, vibrant hub around Harbour Street, packed with independent boutiques, art galleries, restaurants and pubs, as well as quaint shops, churches and cafés stretching along to Oxford Street and beyond.

Like many who move to the town, Douglas West came to love it as his own. As a professional photographer, he had a shop in the High Street and documented not only the lives of many of its residents, but events and changes in the town itself. During his lifetime, he collected images from local people eager that a photographic record of the town be retained for future generations. On his death, this collection was given to the people of Whitstable for their enjoyment and education. Many of the old images in this book are from the Douglas West Collection and a great debt of gratitude is owed to him.

Come to Whitstable to stroll along the beaches and watch the sun set; discover the hidden charms of Squeeze Gut Alley and seek out its maritime heritage. Sample the delights of the local produce, and feast upon fresh seafood; soak in the history, the atmosphere and the invigorating sea air.

One thing is certain about any visit – Whitstable will not disappoint.

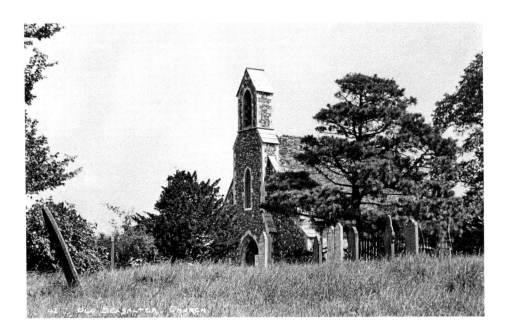

St Alphege, Seasalter

Dedicated to St Alphege, Archbishop of Canterbury, who was murdered by the Danes at Greenwich in 1012, this is the oldest church in the Whitstable district. The colourful Revd Thomas Patten (vicar from 1711–64) referred to himself as the Bishop of Whitstable, his church as a cathedral, and recorded his parishioners in the registers in such terms as 'an old toothless, wriggling Hagg' and 'a young gape-mouth lazy fellow'. Despite construction of the new St Alphege in town, services are still held here today.

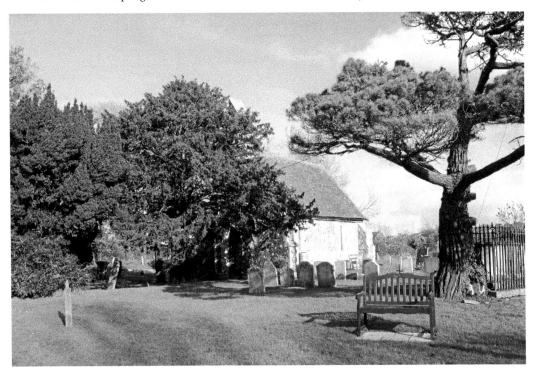

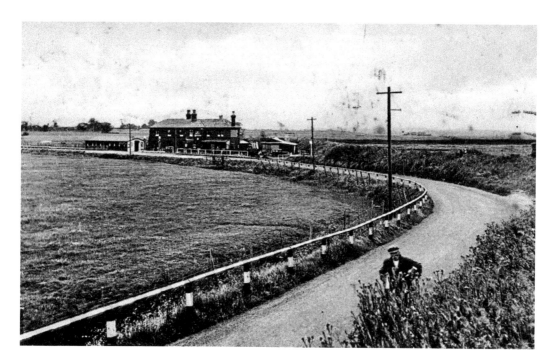

The Sportsman, Seasalter

There is evidence of an inn on this site dating back to 1642. In 1940, soldiers billeted in the pub from the 1st Battalion London Irish Rifles were involved in the last action involving a foreign enemy in this country. The crew of a downed German bomber engaged them on Graveney Marsh and exchanged heavy fire before the Germans surrendered. Today, the pub has a good reputation and a Michelin star.

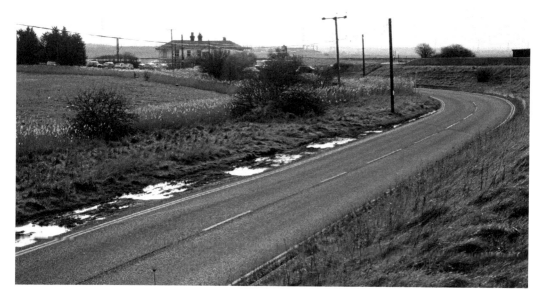

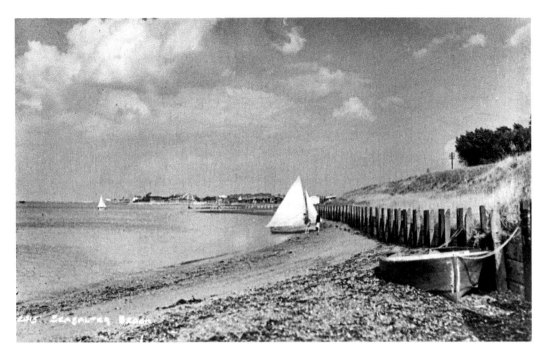

Seasalter Beach

In 1955, archaeologists found salt workings dating from the thirteenth century, confirming the origin of the name 'Seasalter'. The salt was taken through Whitstable and on to Canterbury, travelling through what was known as the Forest of Blean and a section of Clowes Wood. The area is recorded in the Domesday Book as belonging 'to the kitchen of the Archbishop' of Canterbury and is thought to have been an area of food production for the city.

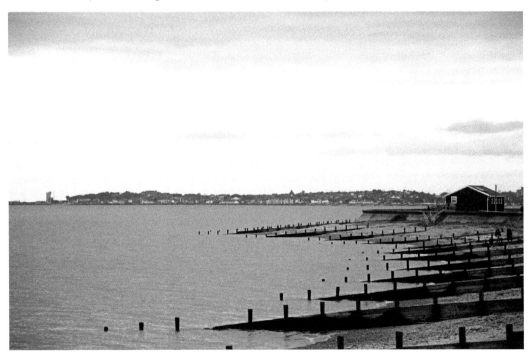

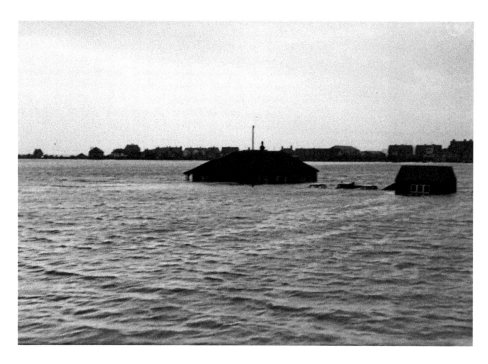

Whitstable and Seasalter Golf Club

In 1911, the Seasalter Golf Club was formed on land that had once been sea, then salt pans, then grazing land for sheep. It was designed for people at the Whitstable end of town 'who would never go so far afield as Tankerton to play', according to Mr A. J. Wilson, founding member. The course, and the town, flooded on 31 January 1953, almost leading to the financial ruin of the club. Happily, play continues today.

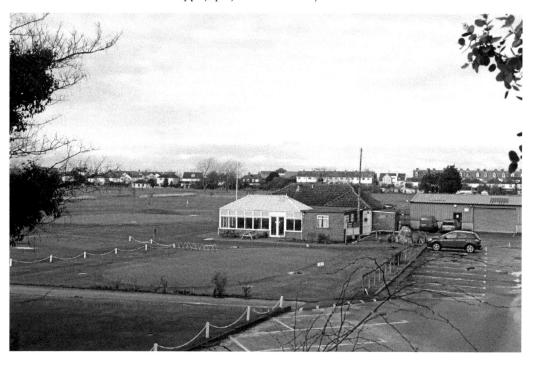

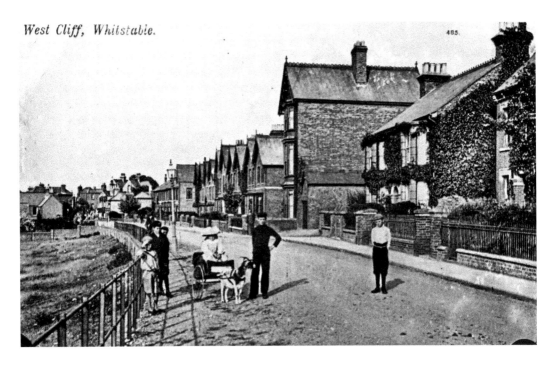

West Cliff

Children would ride in a goat chaise as a means of transport and entertainment, and they were popular around Whitstable and Tankerton during the summer months. Here, at West Cliff, prior to 1910, the field to the left is yet to be developed as part of the Seasalter Golf Club. West Cliff was once the shoreline and references have been found to marine craft and early oyster dredgers being moored over 'The Salts', the present site of Seasalter Golf Course.

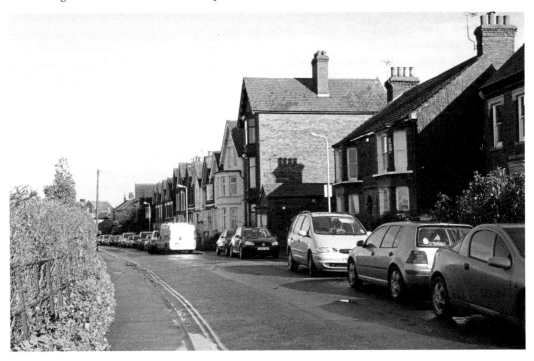

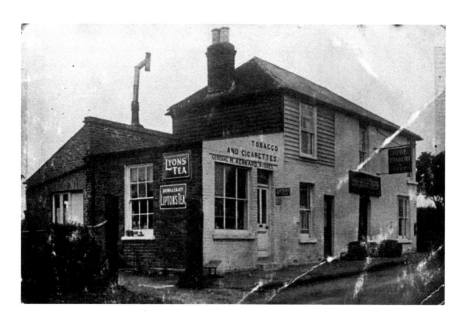

The Long Reach Tavern

In 1858, Stephen Saddleton moved his forge closer to town and the house alongside it became the Long Reach Tavern. A 1903 survey on licensing in Whitstable reported that the pub catered 'for poachers and the roughest elements'. It closed in 1934 and the name was taken for a new pub on the Borstal Hill roundabout. After closing, the old pub became a grocery shop for around thirty years but is now a private house.

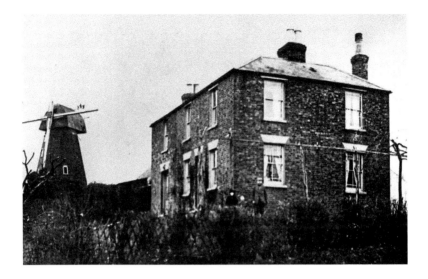

Borstal Mill

The windmill was built in 1792 with four sails and was originally white. It was painted black in the latter part of the nineteenth century and became known as Black Mill. In 1906, the mill and miller's cottage were bought by Henry B. Irving, son of the Victorian actor, Sir Henry Irving. Half-timbered houses around the mill were later replaced by a motel and restaurant, but when these closed in 1987, the site was redeveloped as housing.

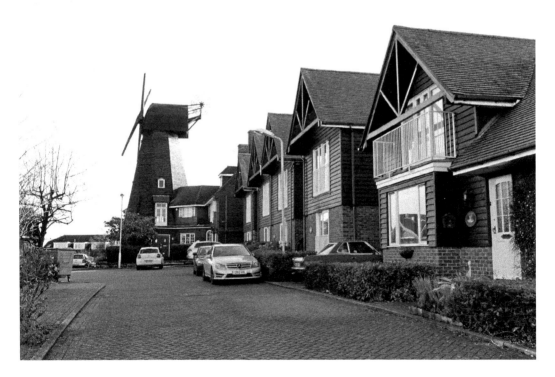

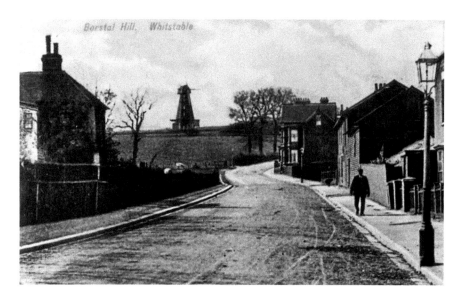

Borstal Hill

Borgsteall is the Old English word for a track or path winding uphill. This later became Bostall, then Borstal. The hill may have been a more arduous climb prior to the removal of some of the crown and the flattening of the hump part-way up during the late nineteenth and twentieth centuries. The top of Borstal Hill now lies under Bexley Street, down in the town, having been used for its foundations.

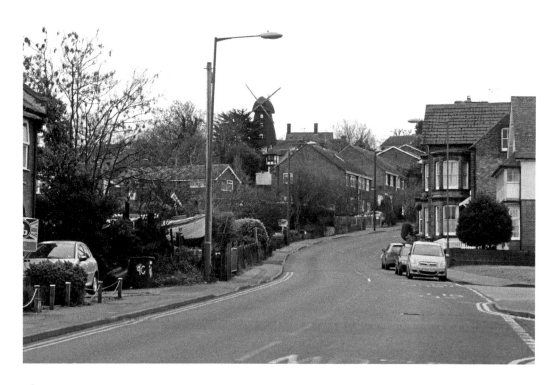

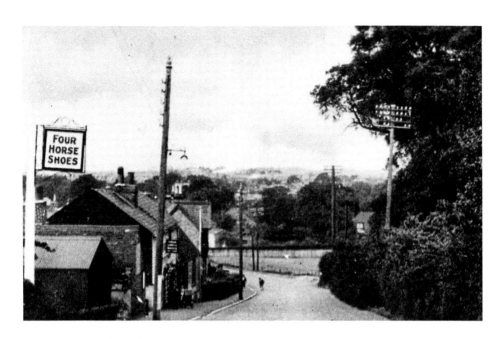

From Borstal Hill Looking North

Established in 1823 beside a blacksmith's forge, the Four Horseshoes was once called the Horseshoe Inn. The weatherboarded cottage preceded the pub, but by the early 1900s the inn was 'much frequented by ... the bicycle rider', according to an early guide for visitors. Shepherd Neame Brewery owned it for a while but it closed in 2013 and has since been sold.

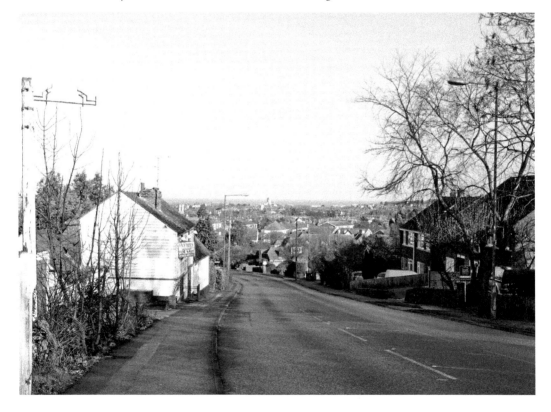

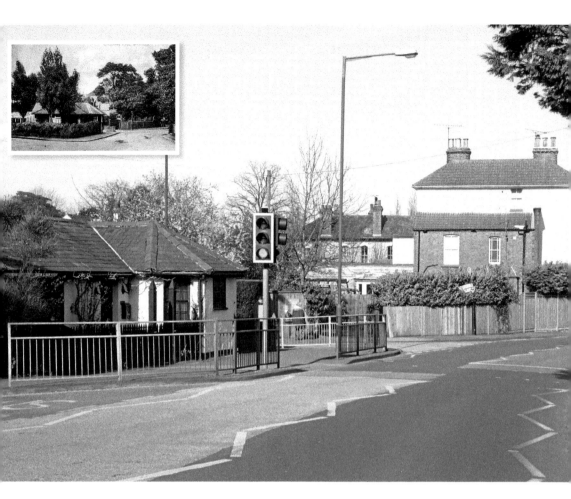

The Toll Gate

The incoming railway line from London meant the toll gate had to move from its original home at the junction of Canterbury Road and Oxford Street. In 1860, it was relocated to its present location on the corner of Joy Lane, at the bottom of Borstal Hill. Tolls were charged for the Canterbury–Whitstable turnpike road from 1736–1871, excepting funerals and wedding parties. The building spent some time as a tea room and local store but is now a private house.

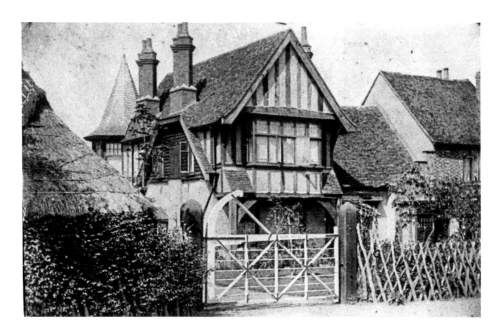

Barn House, Joy Lane

The two roofs to the right formed the original barn, which was built in the fifteenth century and used for many years as part of Joy Farm. George Reeves, local builder, bought the buildings in 1907 with the plan to reuse the materials for new developments, before discovering the historical value of the wattle plastering and king post truss in the roof. Subsequently, he added the Tudor-style cottage and the three buildings formed a single residence.

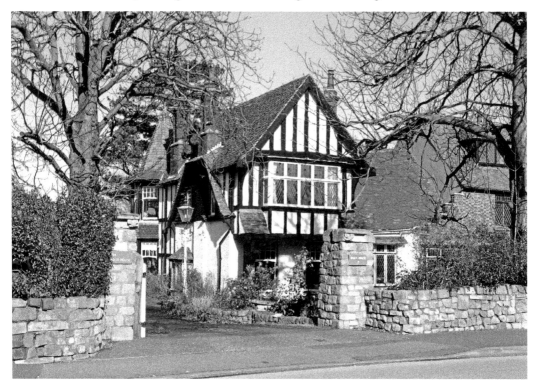

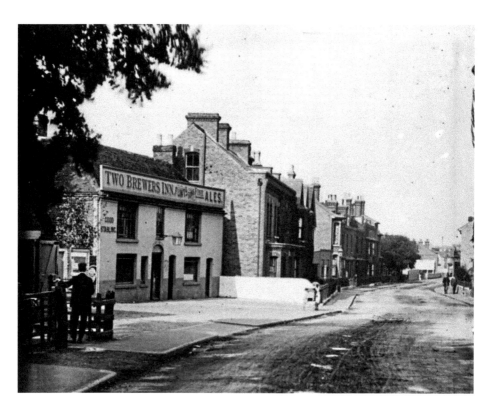

The Two Brewers, Canterbury Road

Supposedly the oldest surviving pub in Whitstable, the Two Brewers has been a public house since 1723, although the building is seventeenth century and was originally built as farm cottages. Merchants using the Whitstable–Canterbury road could rent strong horses to haul their carts up the steep slope of Borstal Hill where their own horses would have struggled. The Two Brewers faced Grince Green, site of the Dredgerman's Fair held in summer on the day of the patron saint of oystermen, St James.

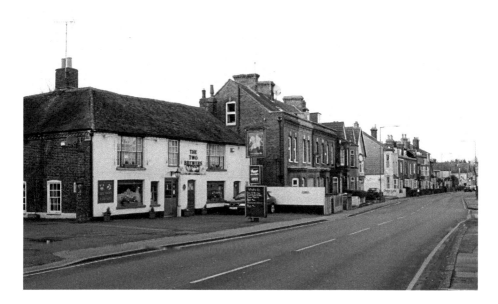

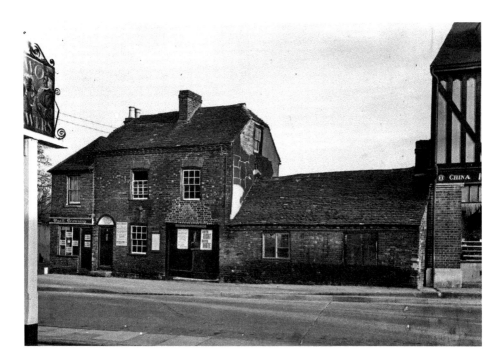

The Old Forge, Canterbury Road

Built in the late 1700s, the business lasted more than 200 years until the coming of the motor car precipitated the demise of many small forges. In January 1934, Charles Dilnott, farrier, murdered the blacksmith William Percy Wills here before committing suicide. Wyatt Browning's furniture and upholsterer's shop was on the corner of Forge Lane. The buildings are now home to an accountancy firm.

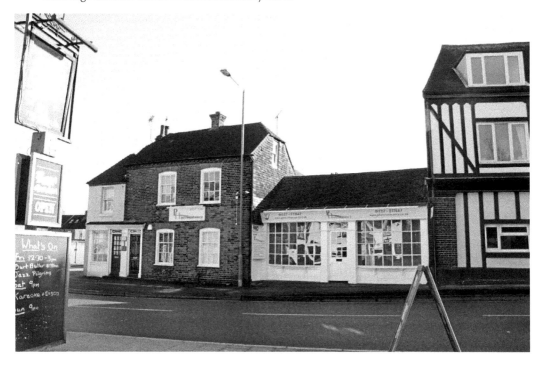

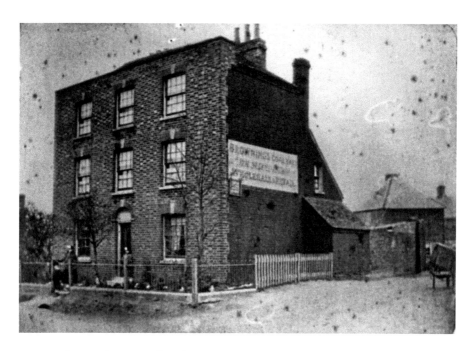

Corner of Canterbury Road and Forge Lane

Owned by Thomas Browning, No. 97 Canterbury Road must have been one of the largest buildings in town around 1880, and was his home and his coal yard. Coal from the North East arrived in the harbour nearly every day and was brought here before being distributed among the residents of the town. Although gas came to Whitstable in 1854, it was only used for lighting. Today, a row of terraced cottages occupies the site.

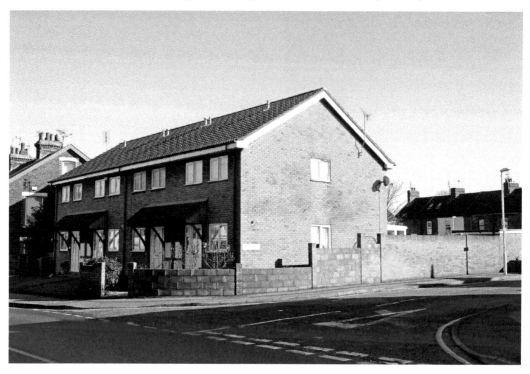

Belmont Road Gasworks and Windsor House
The Belmont Road Gasworks was operational from 1850 to 1932. It produced gas for the town by heating coal in the absence of air to produce coal gas, coke and tar. Three gasometers were used for storage but have now been cleared from the site. In 1968, the twelve-storey block of flats, Windsor House, was opened as affordable housing for elderly local residents. Regarded as unattractive, the building met with some local consternation.

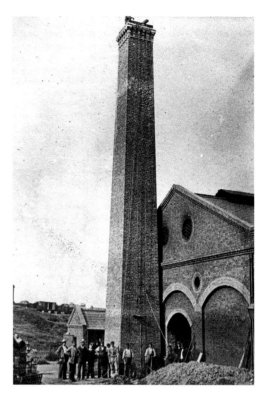

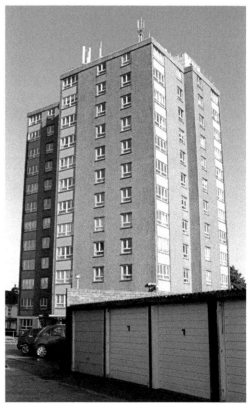

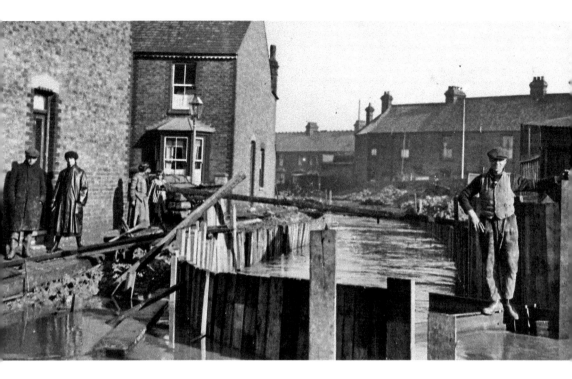

Gorrell Stream and Stream Walk

The lower areas of Whitstable are built on the dried delta of the Gorrell Stream. The open dyke that wound its way through the centre of town was concreted over in the 1920s, and the picture above is likely to show work in progress. Today, it is possible to walk along it from Belmont Road to the end of Cromwell Road, where it flows unseen into the Gorrell Tank.

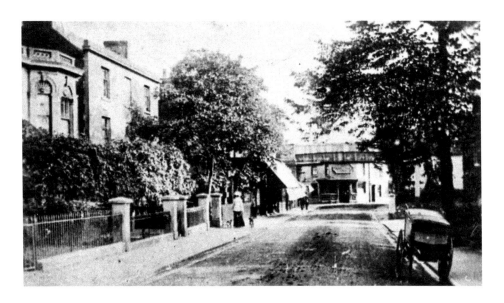

Railway Bridge, Oxford Street

The bridge was erected in 1860 to carry trains along the new main line from London to Whitstable and beyond. Through the bridge, the old Railway Inn is visible, now an art supplies shop. On the left, the railings and brick pillars are all gone, as are the mature trees. Gone too are the box trucks, seen here on the right, which were commonly used for delivering goods.

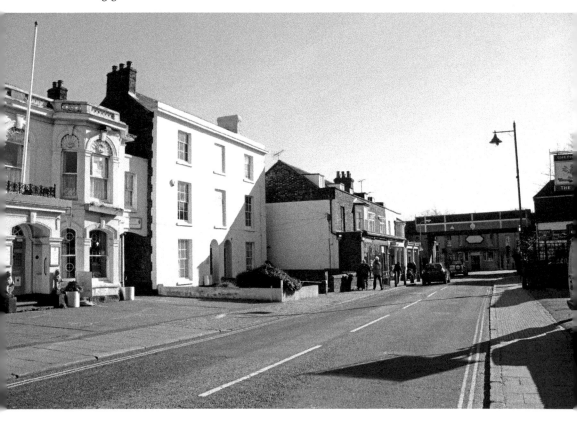

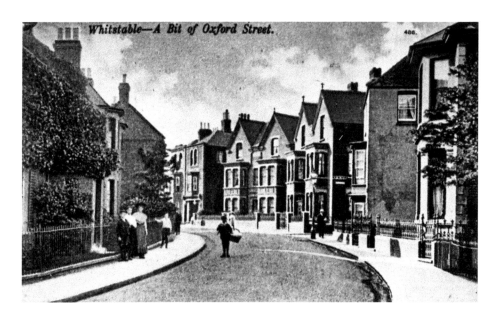

Whitstable—A Bit of Oxford Street.

Oxford Street

William Somerset Maugham attended a school here run by a Miss Etheridge, a relation of Lord Nelson. His uncle, Henry Maugham, was his guardian after his parents' early death and vicar of All Saints church (1871–97), although his relationship with the young Maugham was apparently cold. They lived in a large vicarage on Canterbury Road after the boy arrived in 1884, aged ten. As an adult, Maugham wrote of the fictitious town of Blackstaple, thought to be based on Whitstable.

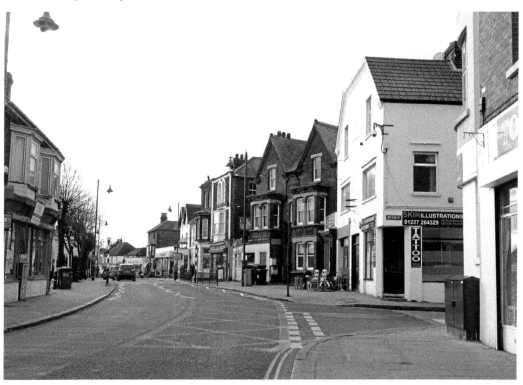

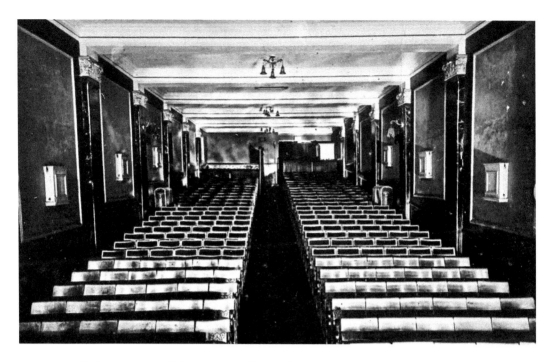

Oxford Picture Hall and the Peter Cushing Pub

The Oxford Concert and Music Hall was replaced by the Oxford Picture Hall in 1912. The Oxford Cinema, far larger with seating for 800, opened in 1936 showing the film *Jack of All Trades,* starring Jack Hulbert, and closed in 1984 with *Blame It on Rio,* starring Michael Caine. It became a bingo hall for a time before it was converted into the Peter Cushing public house by Wetherspoons, which opened on 11 December 2012.

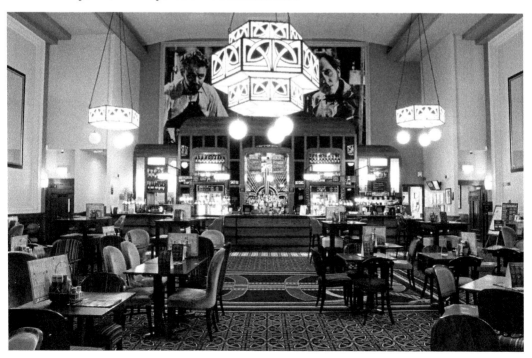

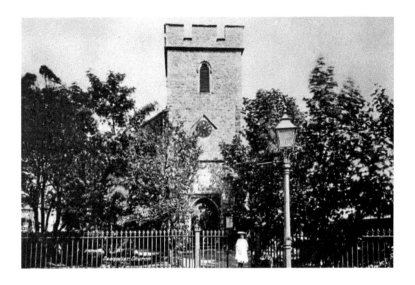

St Alphege Church

In the 1830s, pastoral care in the Whitstable and Seasalter parishes was much neglected, so a new curate was appointed in 1837. He found a population of 8,000 people with few who observed 'the Lord's Day', and 'even the shops [were] not shut'. The new St Alphege church, 2 miles west of the church it replaced, was consecrated on 9 October 1845 by the Archbishop of Canterbury. The railings were removed during the Second World War to aid the war effort.

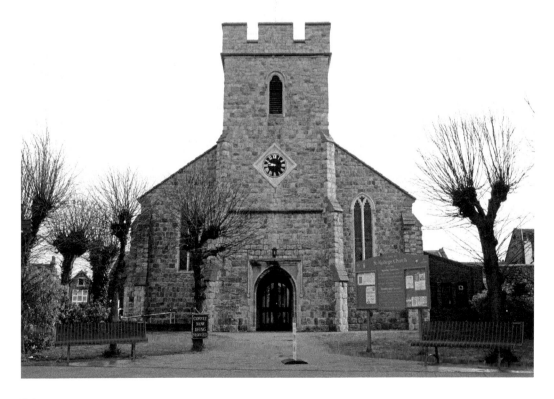

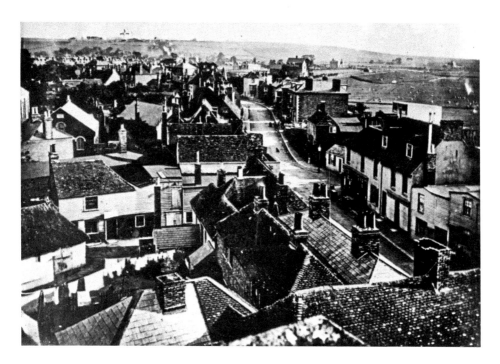

Oxford Street From St Alphege Church Tower

Sheep can be seen grazing on grassland, which is now the Seasalter Golf Club, in the top right-hand corner of this early photograph, dating from around 1880. The tiny cottage at the junction of Oxford Street and Middle Wall has been replaced by Chester House, and the view of Oxford Street is now obstructed by the new Ship Centurion pub, rebuilt in 1913, and much larger than the one it replaced.

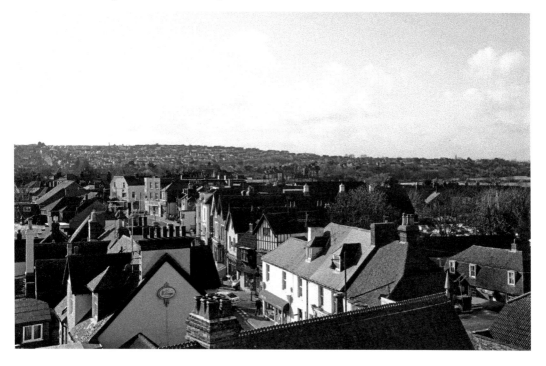

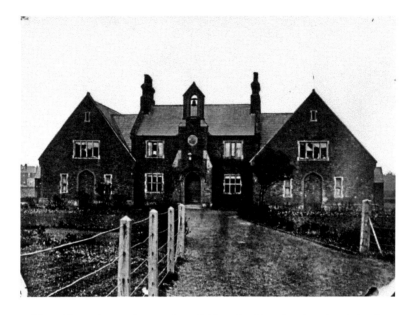

Whitstable and Seasalter Endowed Church of England Junior School
Built in 1845, the same year as St Alphege church, the 'Endowed', as it is
known, was designed to educate 400 children. While easily recognisable,
there have been some alterations, most notably changes to the windows
and the removal of the bell turret and bell.

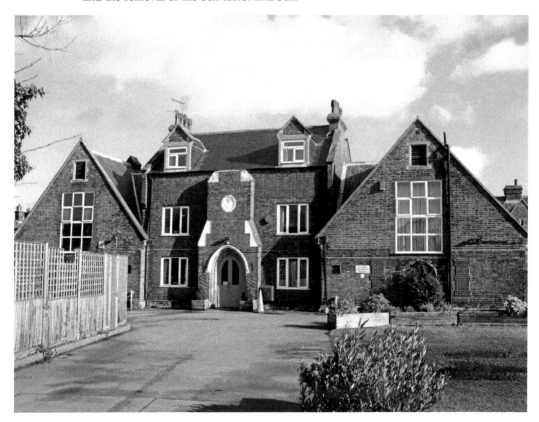

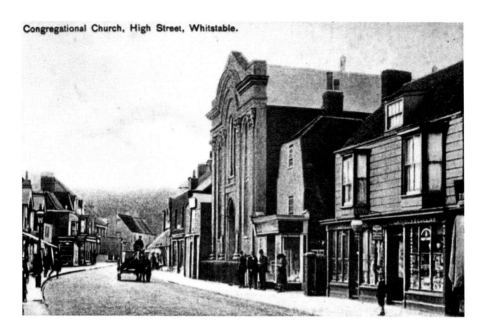

Congregational Church, High Street, Whitstable.

Congregational Church and Playhouse Theatre

This impressive building was originally the Congregational church, which occupied the site from 1792. Destroyed by fire on 5 October 1854, but rebuilt a year later, it was enlarged just after the First World War, when the small shop on the right was demolished to make way for it. The Playhouse Theatre took over the building in 1981 and carried out substantial works to the building's interior before opening with *A Voyage Round My Father* in 1982.

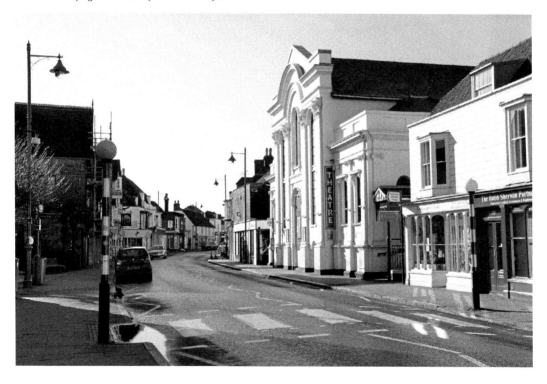

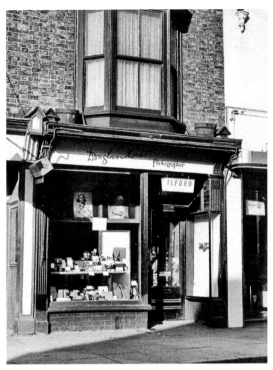

No. 66 High Street

Albert Douglas West came to Whitstable after the First World War when his father opened a greengrocer's shop in Oxford Street. After fixing an old, broken camera, he developed a keen interest in photography. He opened his own shop after the Second World War at No. 66 High Street. The Black Dog became Whitstable High Street's first micro-pub on 22 September 2013.

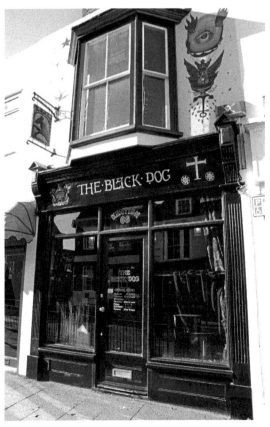

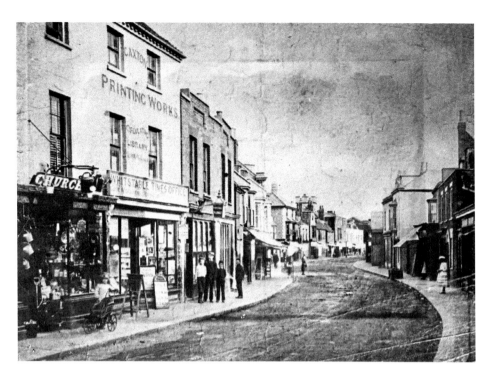

High Street

Seen here in this early image from around 1900, Caxton's Printing Works was established in 1863, later operating as Cox's newsagents until around 2005. It now sells home wares and stylish goods. The Circulation Library was a place to rent books, and George Church's ironmongery shop became Arthur Collier's Ltd, a builders' merchant, now a Boots pharmacy.

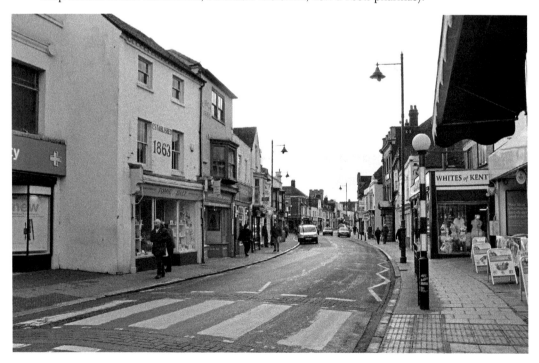

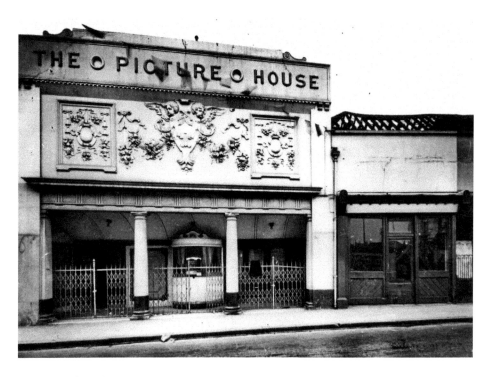

Cinema and Budgens

This cinema operated as The Picture House between 1913 and 1937, then as the Argosy, and, after the Second World War, as The Regal, before finally closing in the 1960s. It was remodelled and opened as the town's first major supermarket, a Fine Fare, later Somerfield and now Budgens. It also previously housed the town's first Chinese restaurant on the first floor.

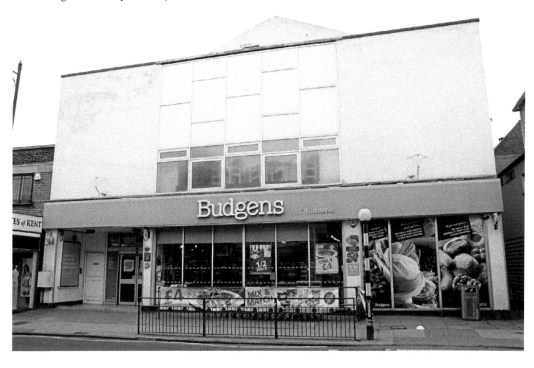

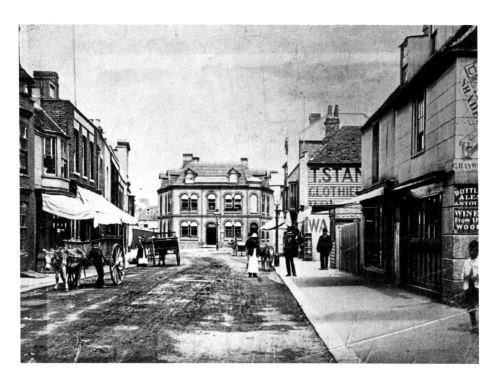

The Duke of Cumberland Hotel

The original pub on this site was called Noah's Ark and was renamed the Duke of Cumberland in 1748 in honour of Duke William, who had crushed the Scottish rebellion at Culloden a year earlier. It was rebuilt after a fire in 1866, and modernised in 1900. It is owned by the Shepherd Neame Brewery and is known for its live music and Salt Marsh restaurant.

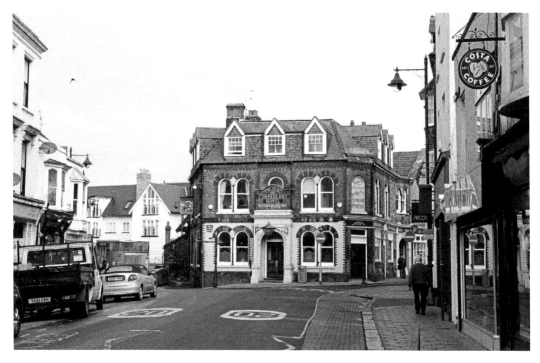

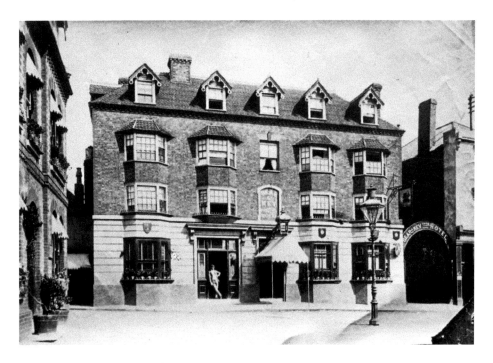

The Bear and Key Hotel and Prezzo

The original pub on this site was called The Ship until William Hogsflesh, its licensee, changed the name to the Bear and Key Hotel in 1739. This early photograph shows two doorways: the left was later replaced with a window, and the archway to the right led to stables and coach houses. The Bear and Key Hotel closed in 2001 to be reincarnated as Sherrins, but this too closed in 2002. It has been home to Prezzo since 2007.

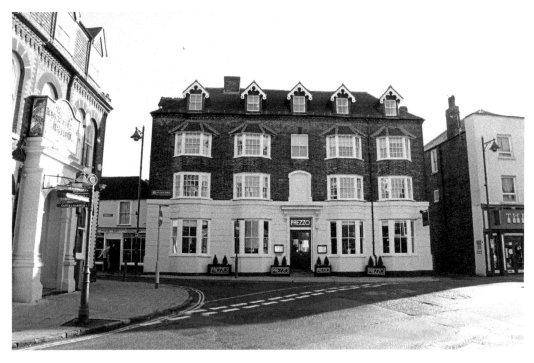

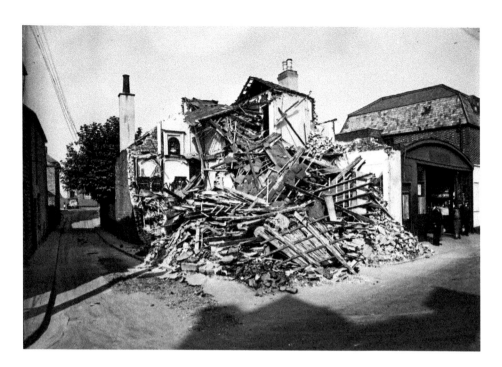

Terry's Lane

Named after Thomas Terry, possibly a coalman with a yard on this road, in 1846. The booking office of the East Kent Road Car Co. stood on the corner with Horsebridge Road until it was destroyed by a bomb on 13 August 1940, leaving the bus garage with the curved roof and the Assembly Rooms untouched. In 2000, a run of shops and flats was constructed with the Horsebridge Arts and Community Centre at the far right end.

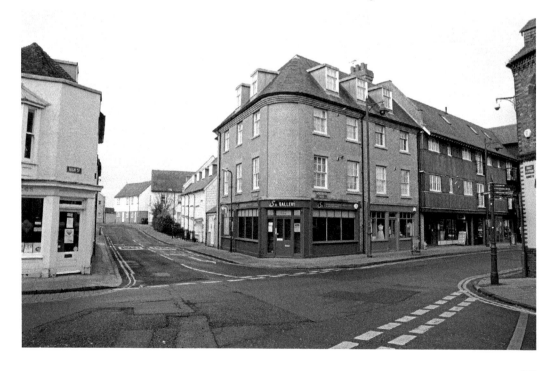

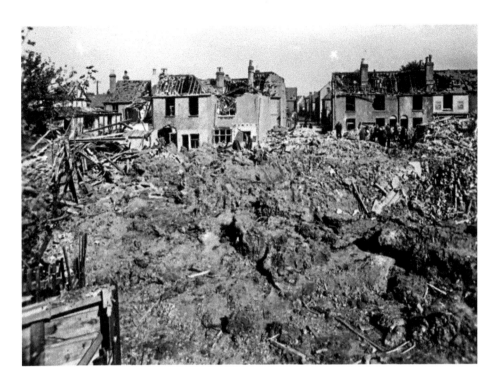

Victoria Street

This area of town was destroyed by a heavy calibre bomb on 11 October 1941. Dozens of houses were destroyed and two people lost their lives, both in the vicinity of a fish and chip shop. The area was redeveloped in 1951 when the Victoria Street flats were built together with a small residents' car park on the corner of Victoria Street and Regent Street.

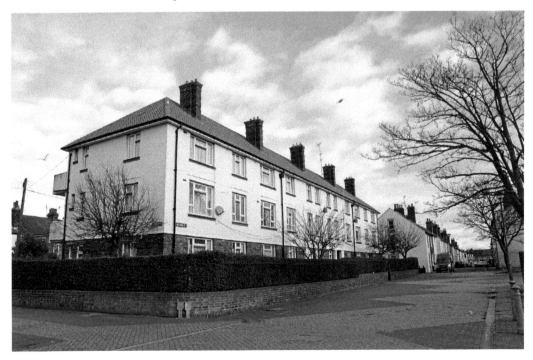

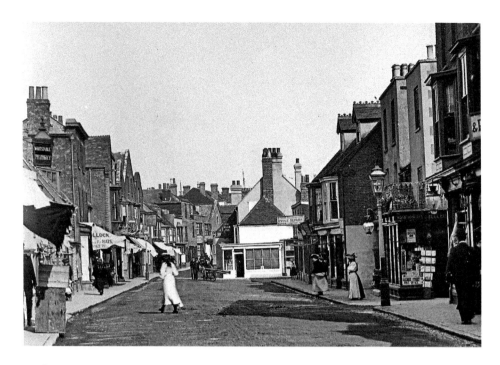

Harbour Street

A fire at this end of town in 1869 destroyed seventy-one buildings in Sea Wall, Marine Street and Harbour Street, with the cost of the damage estimated at £13,000. They were rebuilt, and Harbour Street, with its narrow eastern end widening towards the west, is now home to Whitstable's enclave of independent boutiques, booksellers, restaurants and cafés. It continues to be a popular destination for shopping and dining.

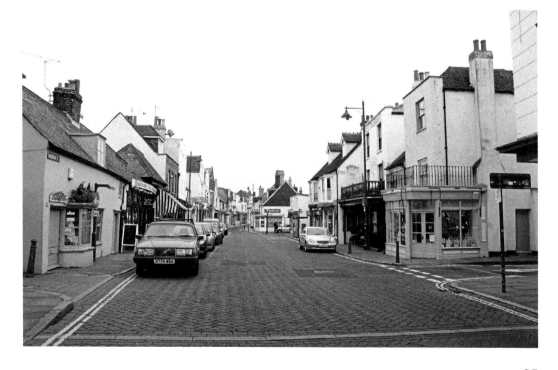

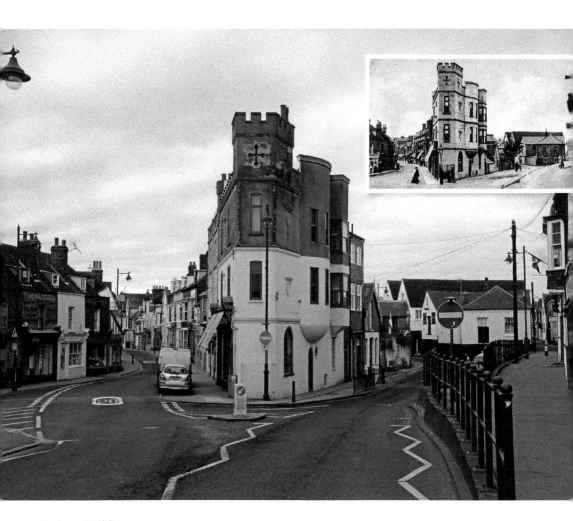

Harbour Buildings

This view is down the narrow eastern end of Harbour Street (the road to the left), and Sea Street (on the right). The castellated building, called Harbour Buildings, was built in the early twentieth century and is seen here around 1905. Opposite, out of sight, was so-called Starvation Point, because no business had any success there; this was demolished and later landscaped into gardens. Today, Whitstable's only one-way system controls the flow of traffic around these once much quieter streets.

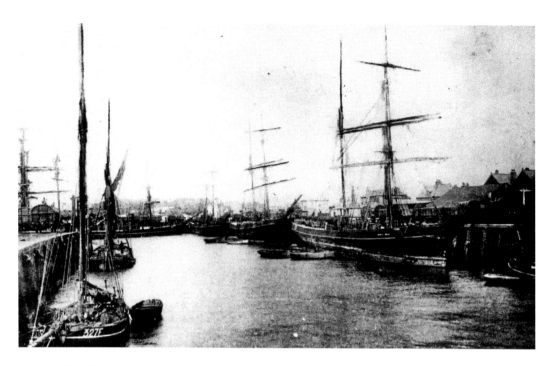

Whitstable Harbour Looking East

A meeting was held with Robert Stephenson in 1828, after which Whitstable Harbour was constructed in 1831 at a cost of £10,000 5s 6d. It was built by David McIntosh and channelled through to the sea on 28 October 1831, finally opening on 28 October 1832. Colliers dominate the quay in this image from 1890, having brought their deliveries of coal from North East ports. Today, it is still a working harbour but fishing boats have replaced the colliers.

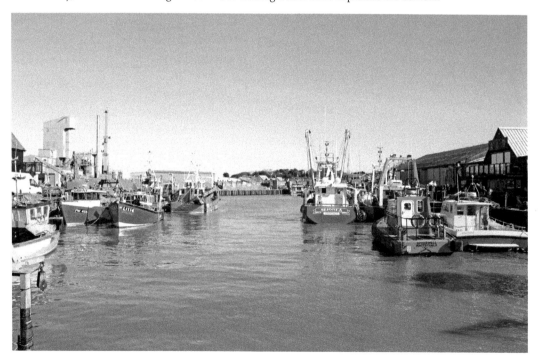

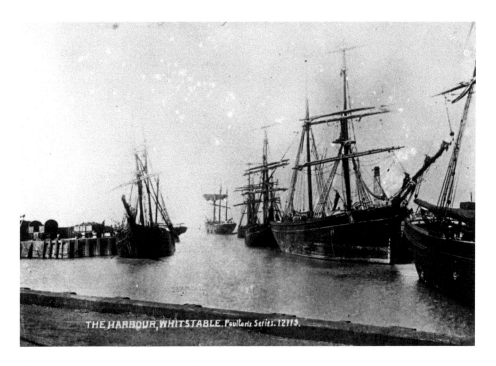

Whitstable Harbour Looking North

The *Raymond* is pictured here on the left, and the *Dolly Varden* on the right, both brigantines. The *Dolly Varden* was originally named the *Sainte Rose* and was built in Bideford, Devon, in 1871. She came to Whitstable in 1877 and was renamed in 1890, operating as a collier until her capture by a German submarine in the First World War. Her crew was removed and she was blown up in the English Channel.

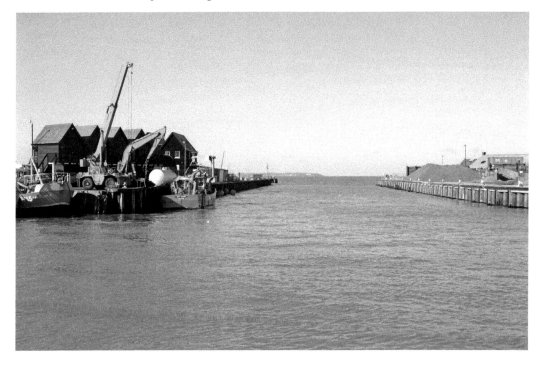

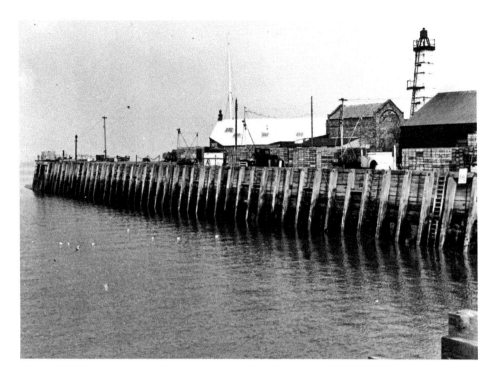

East Quay, Whitstable Harbour

Deterioration led to the East Quay being rebuilt in 1958. This early shot was taken on 19 March 1956. In 1985, a third blacktop plant was built on the East Quay by Brett's, standing 25 metres high and capable of producing over 100 different types of asphalt and tarmac.

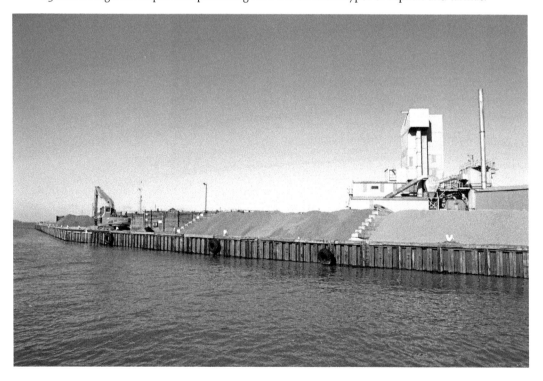

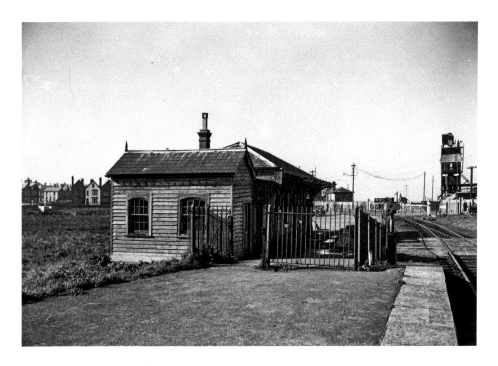

Whitstable Harbour Looking West

This earlier timber building preceded the brick station in the harbour, and was the terminus of the Canterbury & Whitstable Railway, which opened in 1830 as the first passenger and freight service in the world. The terraces of Cromwell Road are to the left, facing what is now Gorrell Tank car park. There has been much speculation over the redevelopment of Whitstable Harbour, but it remains unchanged and, as such, a popular tourist destination.

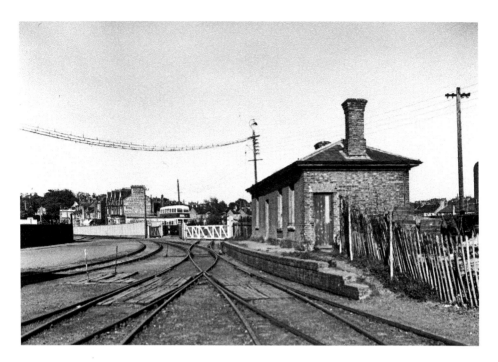

Whitstable Harbour Looking Toward Tower Parade

The railway station was situated inside the gates at the eastern end of the harbour. Trains crossed Harbour Street via a level crossing until the station was resited in 1894 to the south side of Harbour Street, on what is now the site of the Whitstable Health Centre. Tower Parade is clearly visible to the left of the old double-decker bus and level crossing gates in the earlier shot, and is still evident today.

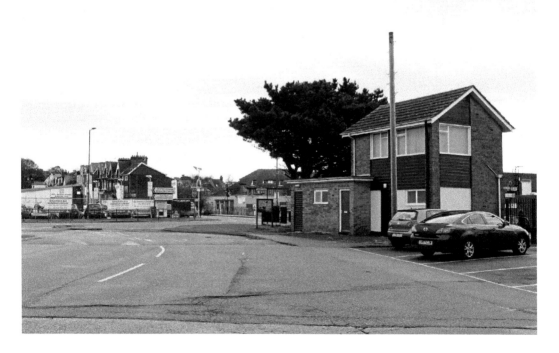

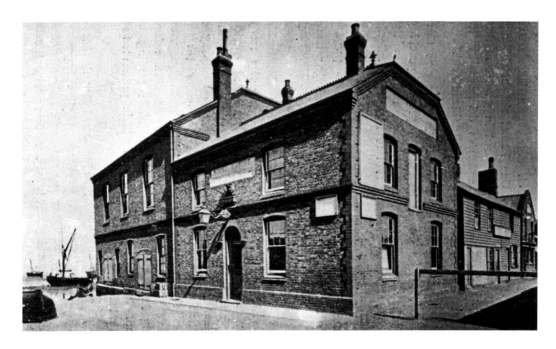

Whitstable Oyster Company

Dating back to the 1400s, the Whitstable Oyster Company claims to be one of the oldest in Europe. Peaking in the 1850s, when supply of the native oyster was plentiful and demand strong from the poor, it sent 80 million oysters a year to Billingsgate fish market, and Royal Appointment was awarded in 1894. This building was constructed in the 1890s by Amos & Foad, local builders. Cold winters, world wars and floods damaged the industry, but interest and customers have returned in recent years.

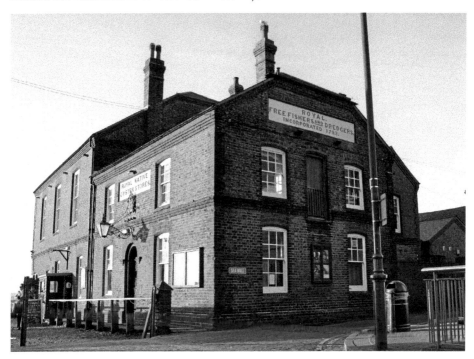

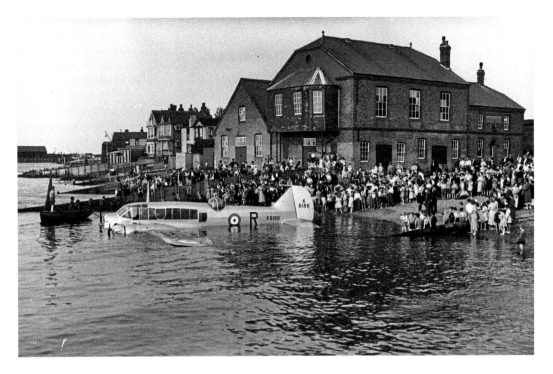

The Horsebridge

This RAF Anson plane from Manston airport was forced to ditch into the sea during an experimental flight in 1936, with little apparent damage to the plane and no harm to the pilot. Note how close the sea is at high tide to the Whistable Oyster Company's building, this being before the loading of the beach as part of the town's flood defences.

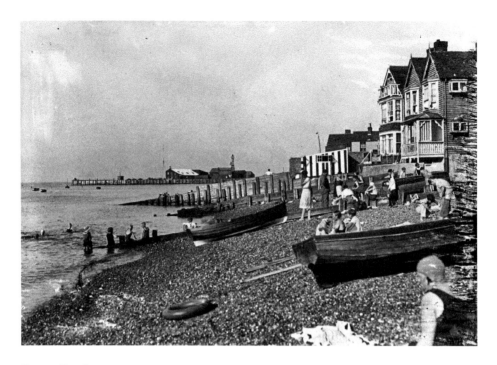

Reeves Beach

Named after a merchant who rented a portion of beach to unload his goods, rather than paying a fee at the Horsebridge, Reeves Beach is where the Blessing of the Waters service is held as part of the Oyster Festival, organised by the Association of Men of Kent and Kentish Men. The festival, which includes the Landing of the Oysters and a town centre parade, gives thanks for the oyster harvest and for the survival of the town's fishermen at sea.

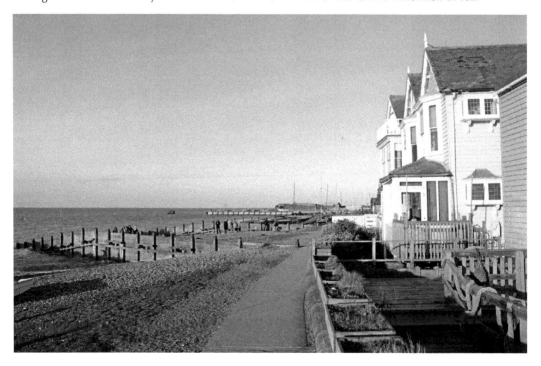

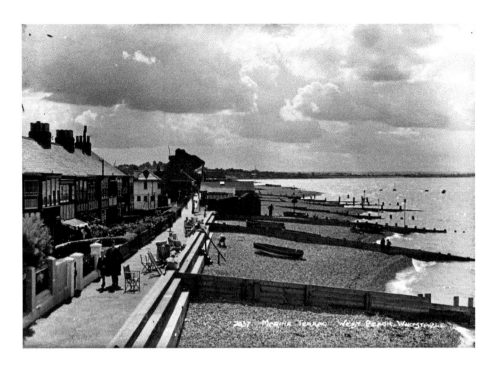

West Beach Looking West

Stretching from the Old Neptune to Seasalter, a large amount of stone has been added to the shoreline at West Beach as part of the town's flood defences. It enjoys the famous Whitstable sunsets and is adjacent to the main beach where the annual Oyster Festival in July culminates with grotter building (hollow structures made of oyster shells) by the children of the town, followed by a firework display just after dusk.

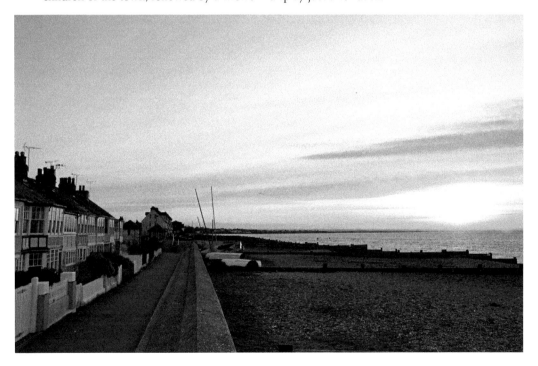

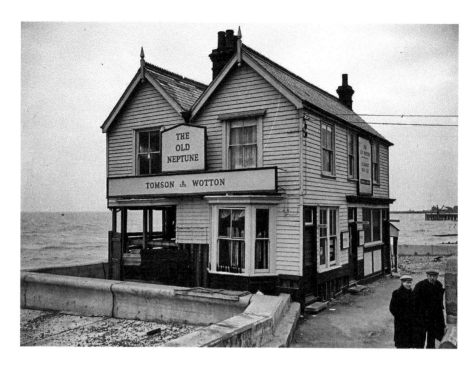

The Old Neptune

Originally a boatbuilding workshop, the pub dates from 1852 and was named after an old oyster smack that was used as a breakwater. The original Old Neptune pub was swept away in the great storm and flood of November 1897. The new Old Neptune was relocated to its present position but sustained damage, seen above, in the storm of 1953. The sea wall around the pub has since been raised.

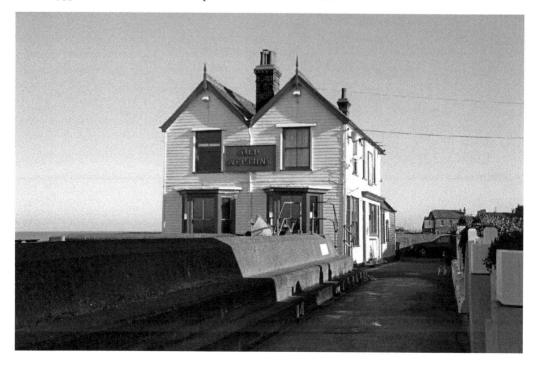

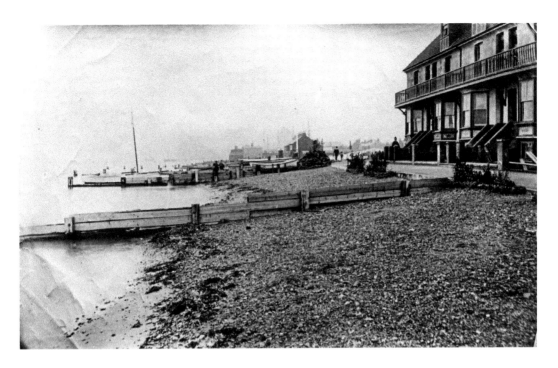

Wave Crest Terrace

Built in the 1890s, Wave Crest Terrace was to provide up-to-date seafront accommodation for visitors. The original Old Neptune pub, destroyed in 1897, is visible in the distance in this earlier shot, which dates the image to somewhere around the mid-1890s. The shingle beach is the first line of flood defence as it breaks up the waves and absorbs their energy. The beaches in Whitstable were widened in the 1980s with shingle dredged from the English Channel loaded onto the foreshore.

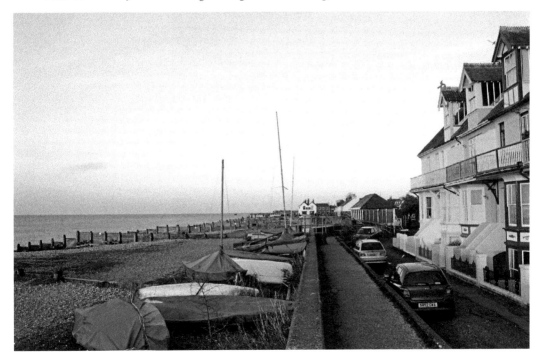

Marine Terrace From the Sea

The house on the far right of Marine Terrace was owned by the Seasalter & Ham Oyster Fishery Company, who had their office there. A race between the oyster farmers of the Thames Estuary took place at the start of each season, with the first to get their oysters to Billingsgate the winner. Next door, where there are tennis courts today, were salt pans and a large boiling shed of the seasalting business, used to evaporate the water.

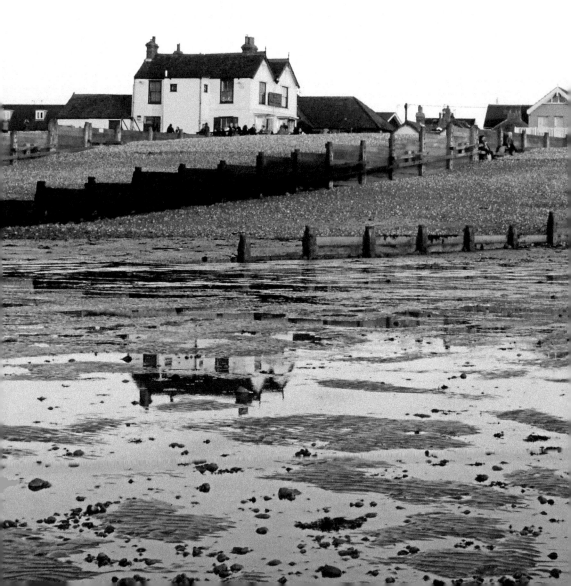

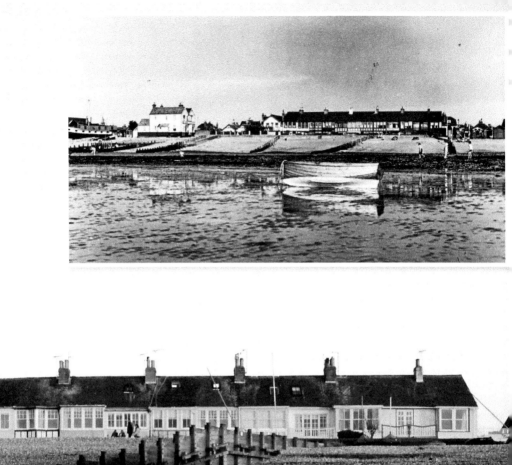

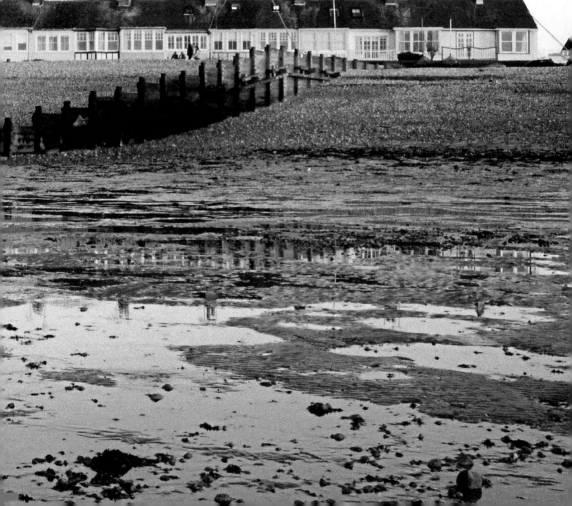

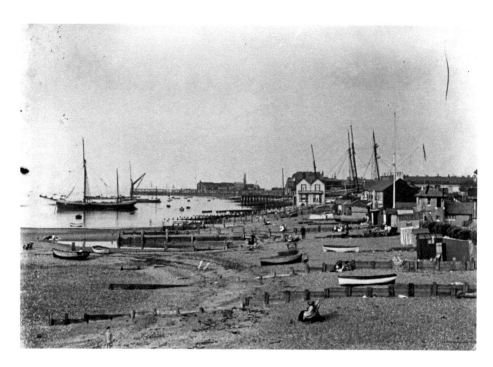

West Beach Looking East

An alternative view of West Beach looking east at low tide. Sailing vessels are moored offshore as well as in the harbour, their tall masts clearly visible over the tops of the buildings. The old Whitstable pier (1913–56) can be seen just to the left of the Old Neptune. It was constructed from timbers from a ship called the *Herbert*, which was broken up. Today's shot clearly shows the new height of the beach.

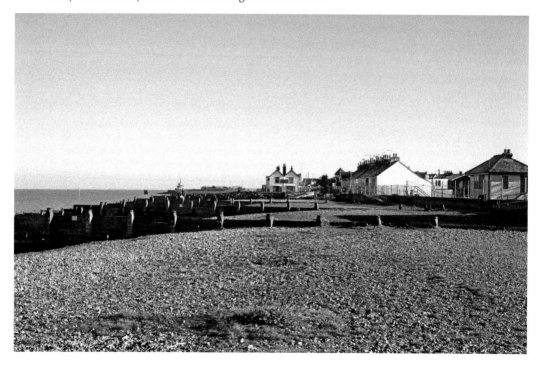

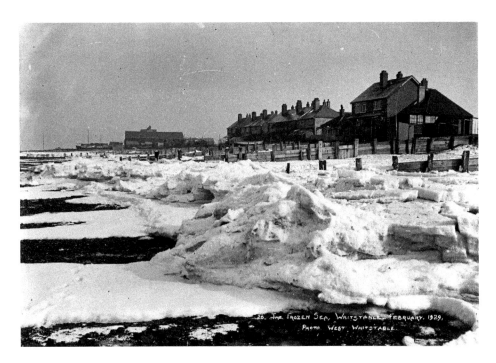

The 'West End'

Seawater freezes at different temperatures depending on how much salt it contains. The resulting ice is very low in salt and the water can be melted down as drinking water. The large volume of river water in the Medway Estuary accounts for the sea freezing at Whitstable, as it has done many times: in 1895, when it froze up to 200 yards from the shore; 1929 (seen here); 1938; 1940; 1947; 1956; 1958; and most recently in 1963.

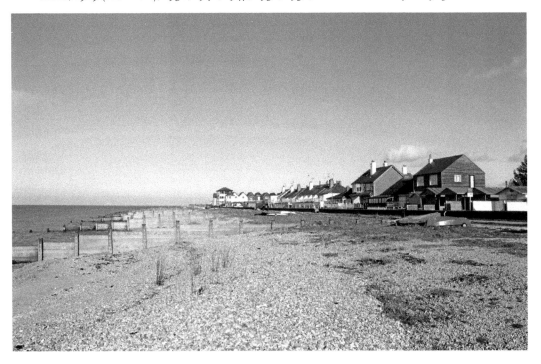

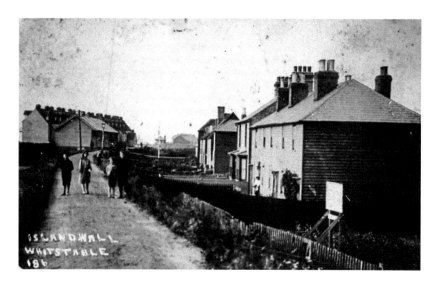

Island Wall

Part of Whitstable's early flood defences, Island Wall is one of Whitstable's most desirable locations. It is home to Dollar Row (not pictured), a run of cottages reputedly built with the spoils from a wreck off the west coast of Ireland. Divers from Whitstable went out in 1851 and returned with a hoard of Spanish dollars. By 1860, Whitstable had thirty to fifty divers who went down to wrecks to recover valuables, with air piped to them by tube up to 100 feet underwater.

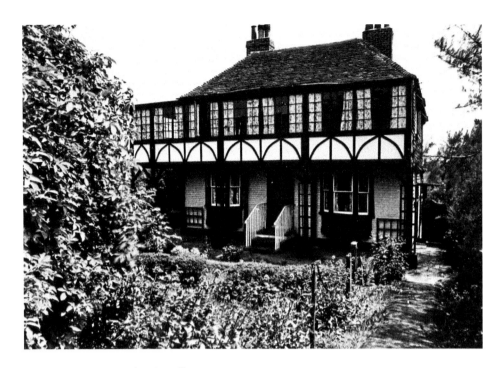

Star House, Lower Island Wall

As the Star public house, it was a popular place with the workers in the shipyards that were once at this end of town. As Star House, it belonged to the son of Lord Fisher of Lambeth (the Archbishop of Canterbury), and Lord Fisher himself resided there for a time. The house backs onto the Seasalter Golf Course and is difficult to recognise as the building it once was.

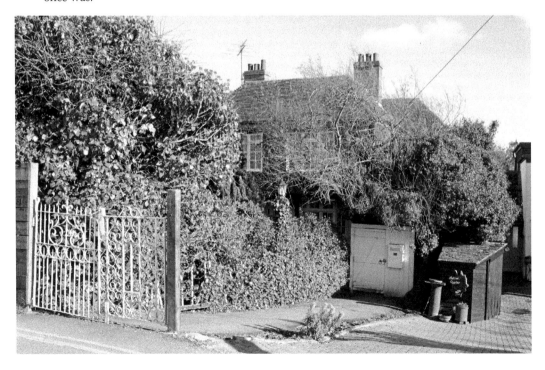

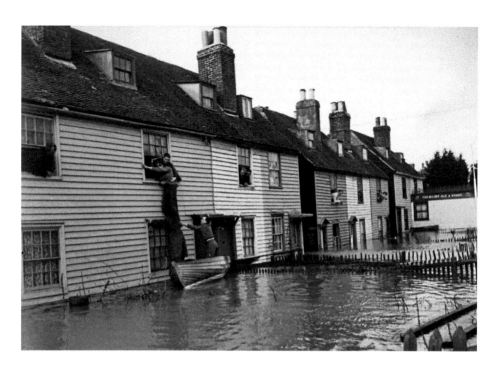

Middle Wall

The flood of 1953 was not an isolated event and spring tides regularly breached the shoreline up to Oxford Street. Middle Wall was constructed in 1583 as part of a flood defence system and, together with Sea Wall and Island Wall, remained Whitstable's main protection for many years. Today, the shoreline has much new stone, the sea wall has been raised and floodgates are installed during tidal surges and large storms. These cottages were demolished as substandard housing and the area is now a car park.

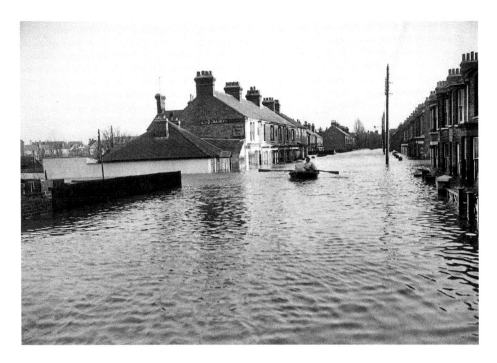

Nelson Road

In 1953, the floodwater in Nelson Road reached the middle sash of the windows on the ground floor of the houses, but had receded slightly by the time of this photograph, leaving behind its watery mark. Rowing boats were used to rescue people from their upstairs windows. Around 160 years earlier, the shoreline would have been along the line of Oxford Street and West Cliff, and Nelson Road would have been submerged.

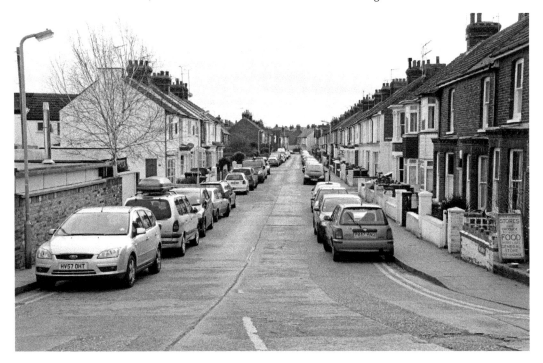

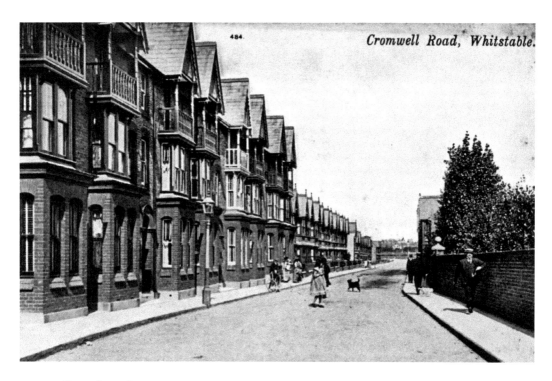

Cromwell Road South

This imposing terrace was built around the turn of the twentieth century by Amos & Foad, who were based in Millstrood Road with an office on Oxford Street. The wall to the right in the earlier image is the boundary for a residence on the corner of Cromwell Road and Oxford Street, later extended and used as a doctor's surgery and now a private residence once more.

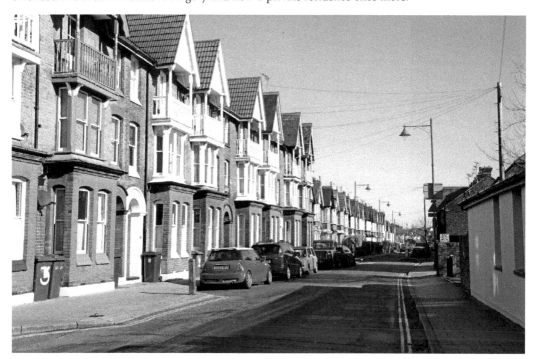

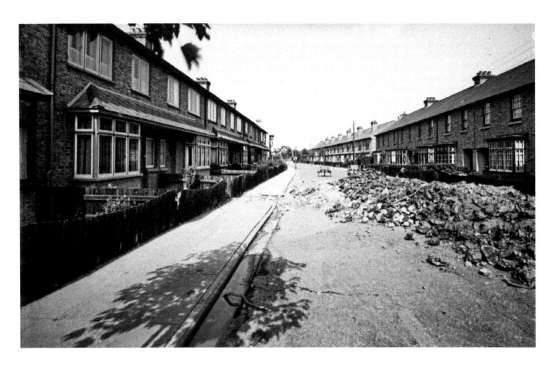

Acton Road

New houses in Acton Road were sold for £475 in 1926: £75 down and 15s 3d a week thereafter. Before the official declaration of war on 3 September 1939, the evacuation of 4,000 children from Rochester to Whitstable had begun. They were removed in the belief that only industrial areas were at risk of being bombed. Even so, beach huts were replaced with steel and concrete structures and military exclusion zones were established along the coast.

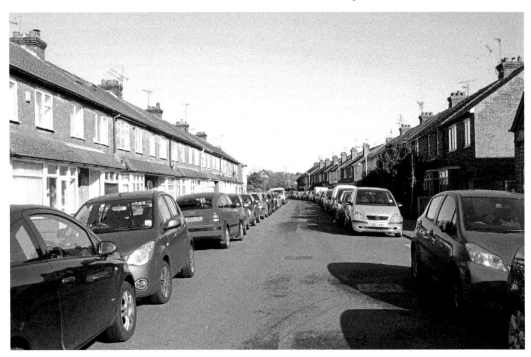

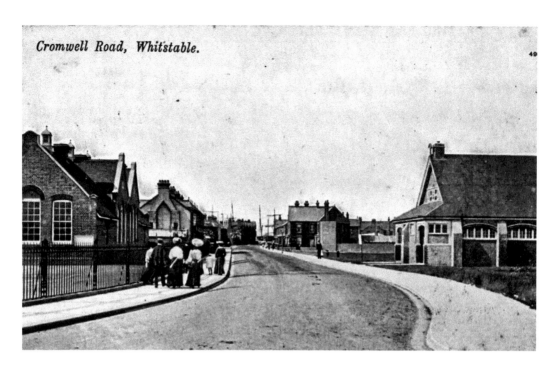

Cromwell Road, Whitstable.

Cromwell Road North

Westmeads Community Infant School, seen here on the left, was commissioned by the newly established Kent Education Committee, based at Maidstone and built in 1904. It replaced another infant school in Albert Street, which dated from 1879. The first state school in town was the Oxford Street School, which opened in 1877. The hall on the right is St Peter's Church House, acquired in 1937 for £500.

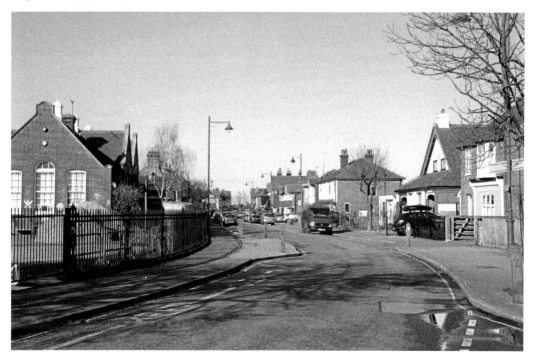

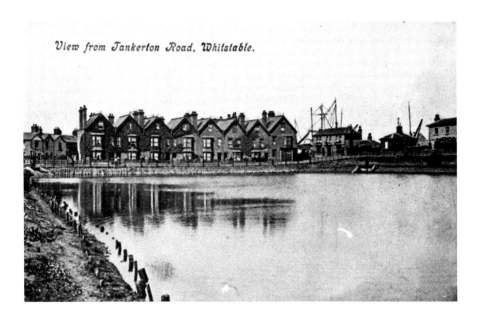

View from Jankerton Road, Whitstable.

Gorrell Reservoir and Gorrell Tank

This early view of the Harbour Street end of Cromwell Road is taken across the Gorrell Reservoir, known locally at the time as the Backwater. Built to flush silt from the harbour, it would fill with water from the Gorrell Stream and drain with the tides. It was largely ineffective and the harbour is regularly dredged today. The reservoir was concreted over in the 1970s with the installation of a tank below; the area is thus now known as Gorrell Tank.

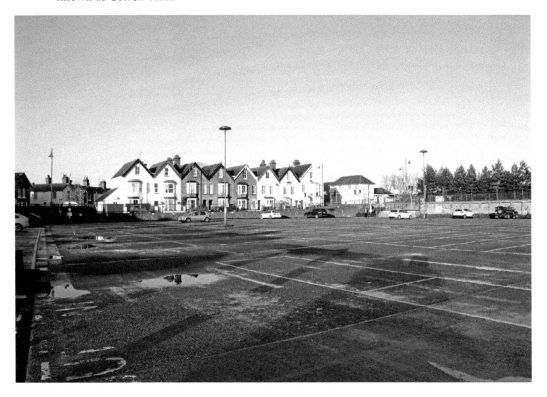

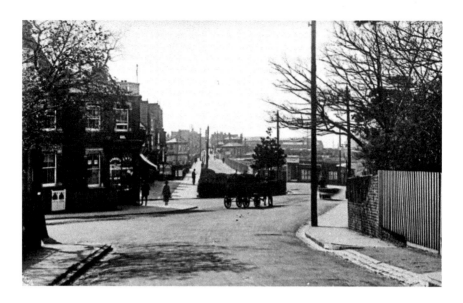

Tankerton Road Looking Towards Harbour Street

The railway signal box sat on the southern side of Harbour Street, at the end of Tower Parade, to control the level crossing that traversed the road here. Opposite, the station, built in 1830, sits just inside the harbour. A bakery and tea shop occupied the corner shop at the junction of Northwood and Tankerton Roads around 1920. Today, the sweep of the gardens jutting into the road has been reduced to little more than a bank of shrubbery.

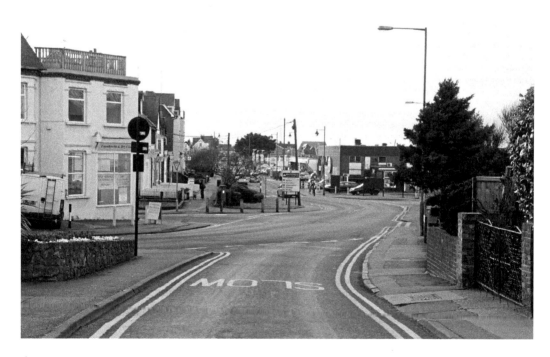

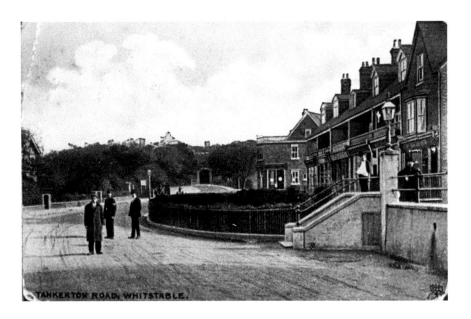

Tower Parade

The road once ended at Tankerton Green, before Tankerton Road and Northwood Road were laid, as had recently been the case in this early image, taken *c.* 1900. Queen Victoria's Jubilee Memorial Drinking Fountain was erected in front of Tower Parade in 1897 for her Diamond Jubilee, complete with an inscription, green-glazed tiles and a heavy iron drinking mug on a chain, but was gone by the 1920s. Today, a parade of shops occupies the site.

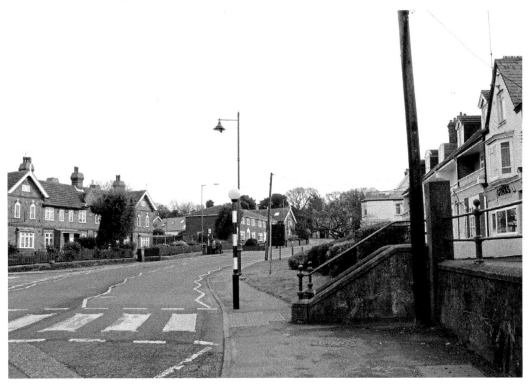

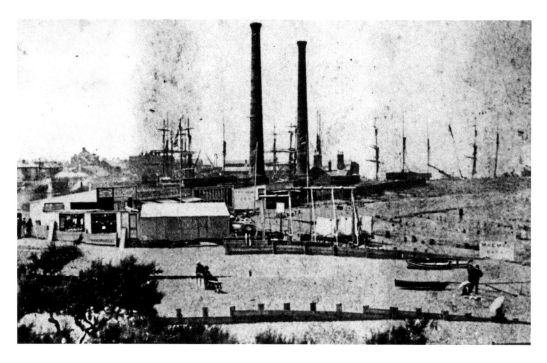

Looking West Toward East Quay

The first locomotives serving the Canterbury & Whitstable Railway were coke fired. Consequently, two coke ovens with tall chimneys were built between East Quay and the beach to convert coal into coke. They produced coke for thirty-three years until coal-fired locomotives were introduced in 1880. When the ovens and chimneys were demolished in 1892, their rubble was used for the foundations of the houses and roads being built at Tankerton. Today, Brett's tall tower dominates the skyline instead.

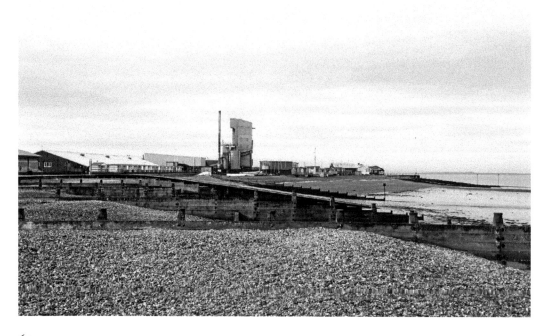

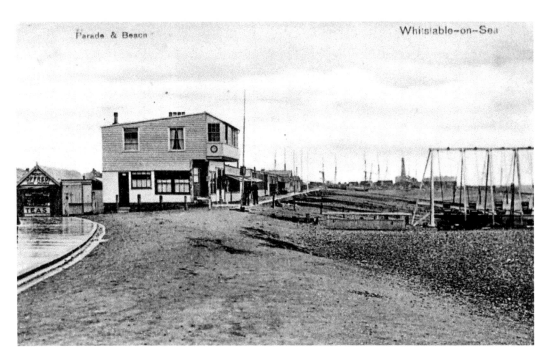

Long Beach

The stretch of beach from the harbour basin to The Street is known as Long Beach, and Tankerton Beach runs from The Street, along the length of the slopes. In this early shot, the masts of sailing vessels in the harbour are visible above the buildings and Offredi's tea hut is on the far left. Today, the Whitstable Swimming Pool occupies a beachside location next to the waterfront on the corner of Beach Walk.

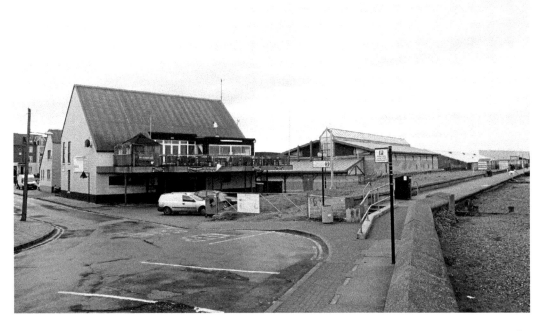

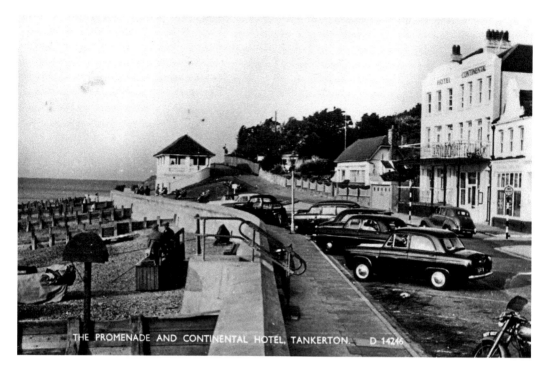

THE PROMENADE AND CONTINENTAL HOTEL, TANKERTON. D 14246

Hotel Continental

Refurbished in 1998, the Hotel Continental not only provides bricks and mortar accommodation for visitors to Whitstable, but also runs eight converted fisherman's huts as accommodation close to the beach. Before the promenade was built, walkers would take the rising path up to Tankerton Slopes or walk along the pebbles to The Street and beyond.

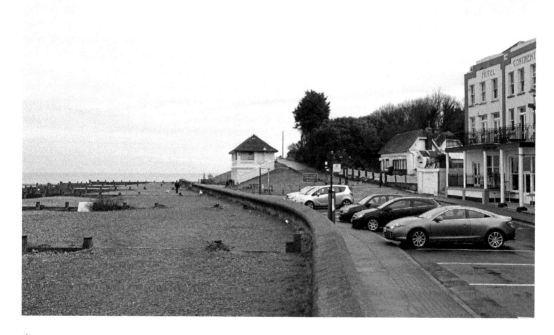

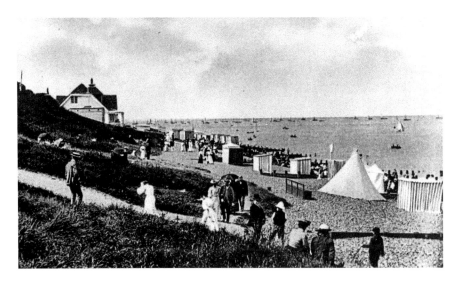

Tankerton Beach

The early popularity of the beach around 1910 is evident, as is the modesty of dress. This was due, in part, to an aversion to suntanned skin but, more importantly, the social mores of the time. The bathing cabins provided a discreet place for ladies to change. They were then wheeled a short way into the sea so they could enter and exit modestly. Men, particularly those of the working class, were more immodest, willing to frolic naked despite attempts to ban the practice.

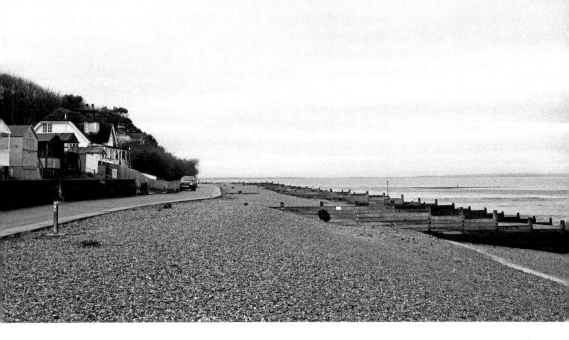

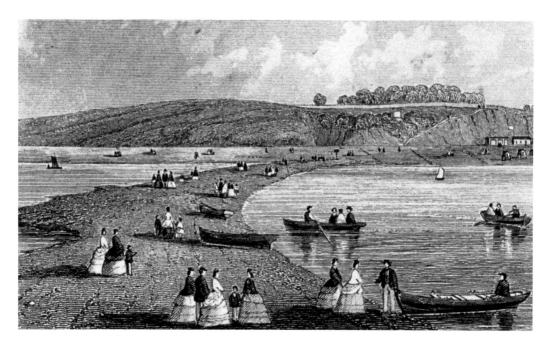

Tankerton Slopes From The Street
Copperas mining was focused on the area of the slopes east of The Street. Cornelius Stephenson was granted permission by the Crown to exploit copperas from the shore in 1565, and the resulting mineral was used principally for dyeing clothes. Production had ceased by the late 1820s, and the Tea Gardens occupy the site today, together with Whitstable Castle and part of Tankerton Slopes.

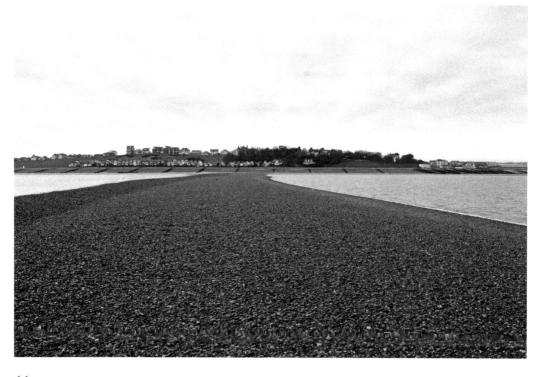

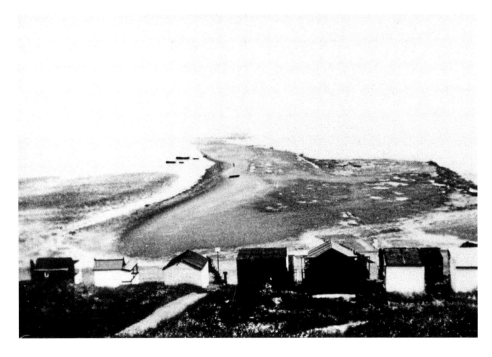

The Street, Tankerton

A natural strip of shingle juts out from the beach, protruding about half a mile out to sea. It is only visible at low tide when it is possible to walk out along it, hence its name. It is a remnant of the Swale river valley, and is a stunning natural feature of the landscape. Directly out to sea lie the Red Sands sea forts, built by Guy Maunsell to protect shipping lanes from attack by German aircraft during the Second World War.

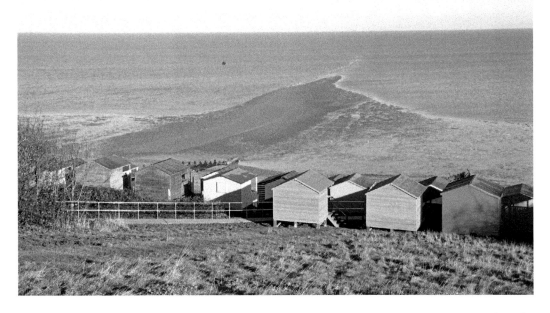

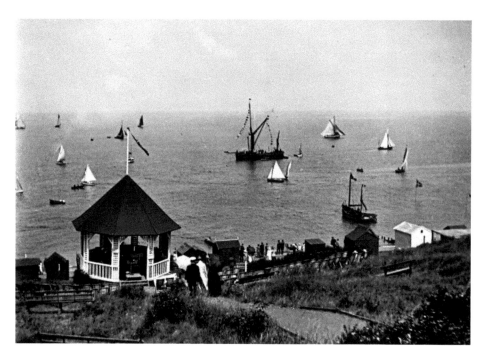

Tankerton Slopes Looking North
Built at a cost of £85 by Thomas Porter, the bandstand on the slopes was designed by George Reeves and opened in 1912. Despite being retained initially, the sound of the Whitstable String Band was not strong enough to carry in the open air and an Anglo-American Guards Band was engaged instead. The First World War interrupted the concerts, which then continued until the bandstand was demolished in the 1940s.

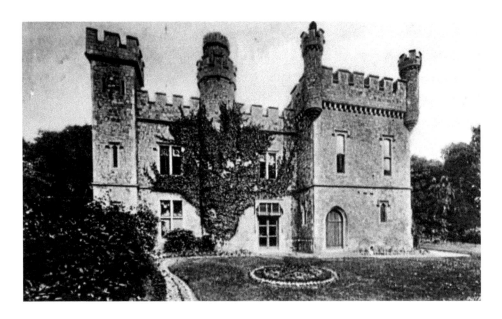

Tankerton Tower and Whitstable Castle

Tankerton Tower was built 1790–92 by Charles Pearson, a London businessman, as his weekend home. Wynn Ellis MP installed his mistress here in the mid-nineteenth century, and Albert Mallandain added the large billiard room in the 1920s. In 1935, the building was purchased by the local council and used as their offices for the next forty years. It was also renamed Whitstable Castle. A lottery-funded project restored the castle in 2008 and it is now used as a community resource.

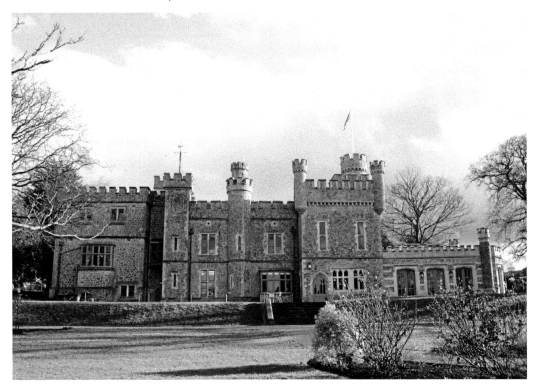

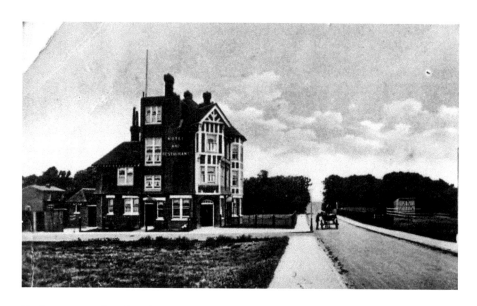

Tankerton Hotel and Tankerton Heights

When telephones were introduced to Whitstable, the Tankerton Hotel was allocated No. 24 and was among the first of the commercial properties and the well-to-do of the town to be connected. The business later operated as a pub, but has now been converted into flats and is known as Tankerton Heights.

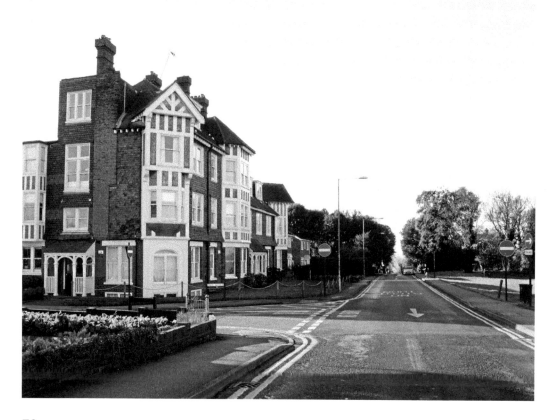

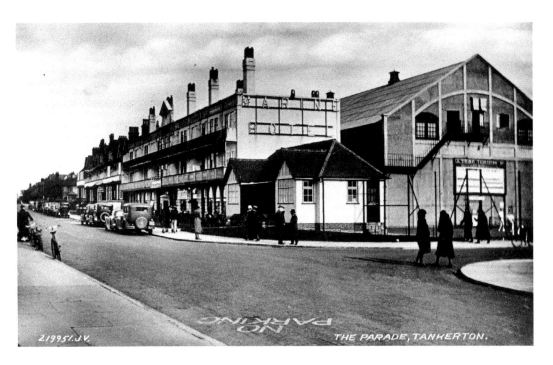

Corner of Marine Parade and St Anne's Road

The Trocadero was Tankerton's very own cinema, built in the late 1920s and operating until the late 1940s, or possibly the early 1950s. It stood behind the Tankerton Grand Pavilion, which housed the entrance, and was affectionately known as 'the Troc'. *King Kong* was shown here in 1933, and it was used for war work during the Second World War. Reopening as the Embassy, it closed again after only a couple of years. Part of the area is now a tennis court.

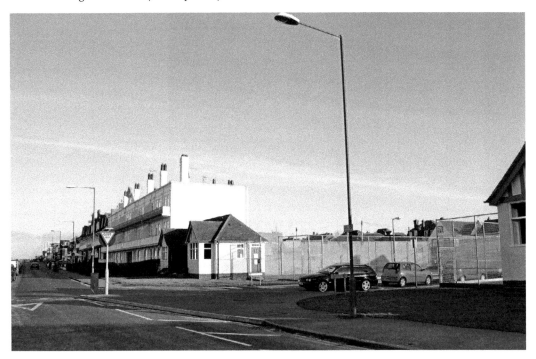

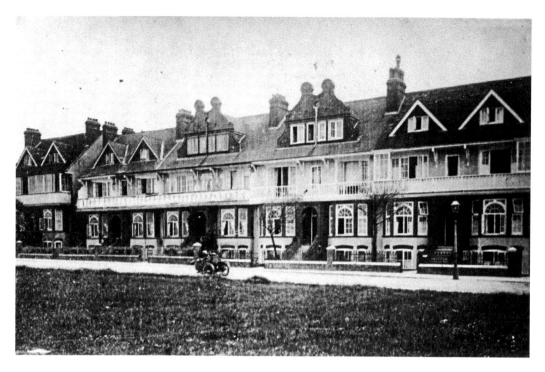

Marine Hotel
Originally built as Cliff Terrace, the Marine Hotel began life as a row of six terraced houses on the Tankerton estate at the beginning of its development. During the First World War, it was used as a military hospital. In 2013, the Shepherd Neame Brewery spent £1.6 million on its refurbishment and it is now a hotel, bar, restaurant and wedding venue.

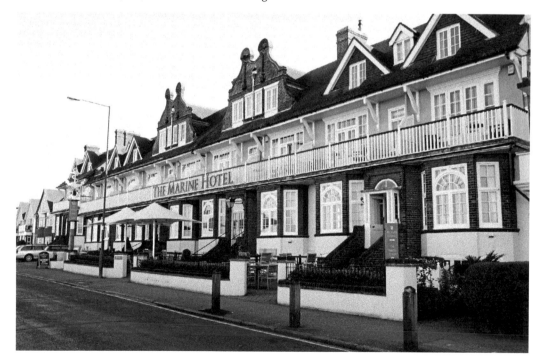

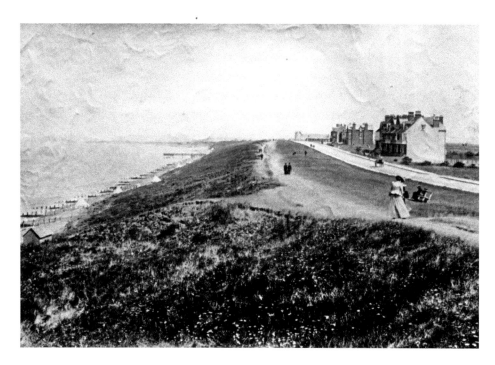

Tankerton Slopes Looking East
This is one of the earliest known photographs of the area. The white building, built in the 1890s, was Cliff Terrace and is now the Marine Hotel. The pier is clearly visible further along the shore. Building in Tankerton was sporadic at first, with many plots not developed until the 1930s. This piecemeal construction resulted in the unique nature of the estate, with its individually planned and executed houses.

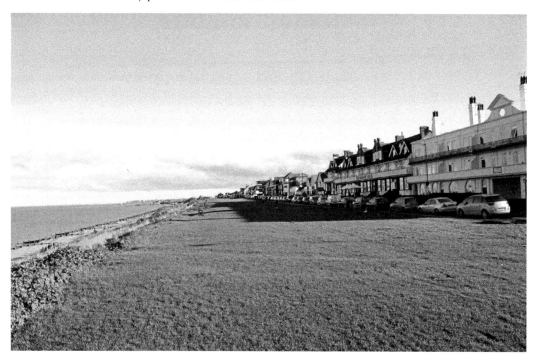

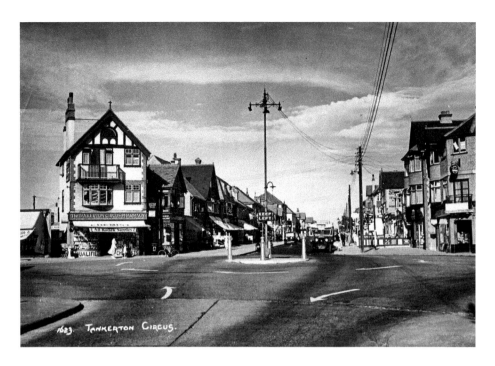

Tankerton Circus

Electricity came to the area in 1914 with the formation of the Whitstable Electric Company, but the road to Tankerton wasn't laid until around 1920. This area of the Tankerton Road became the focus for local shops and cafés. A development had been planned at Pier Avenue over twenty years earlier, but this never came to fruition. Today, the roundabout has been expanded and planted with palm trees, which thrive in Whitstable's sunny climate.

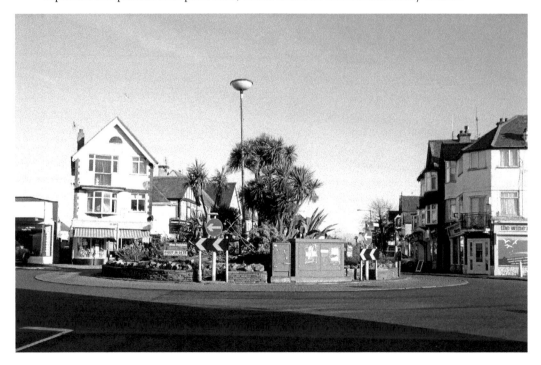

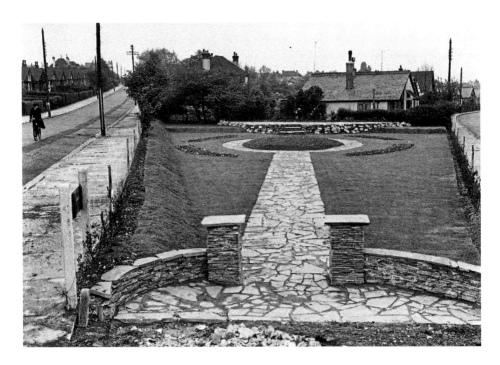

Kingsdown Garden, Tankerton Circus

Intended to attract visitors as part of the original Tankerton Estate, Kingsdown Park was installed in 1892. In 1910, it was let to the Chamber of Commerce for games and concerts but was later divided into plots and developed. The nearby, and much smaller, Kingsdown Garden, at Tankerton Circus, was donated to the people of Whitstable in 1952 by former councillor and town clerk, Fred Goldfinch (1861–1956).

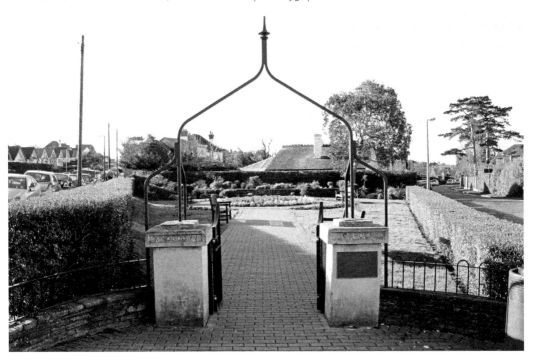

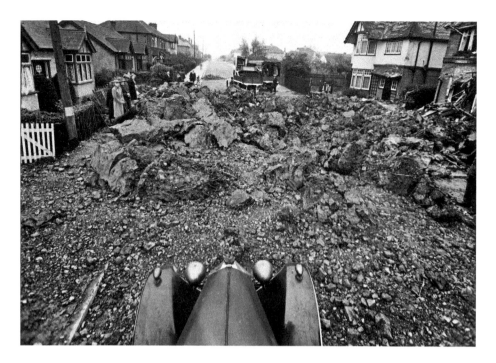

Graystone Road, Tankerton

During the Second World War, ten civilian lives were lost in Whitstable, thirty-five people were seriously injured, and 118 suffered slight injuries. During the Battle of Britain in 1940, seven lives were lost through bombing. After that, there were just two incidents: one in Victoria Street, thought to be a sea mine intended for the shipping lanes; and the second, a V2 that fell on All Saints Close, short of its London target.

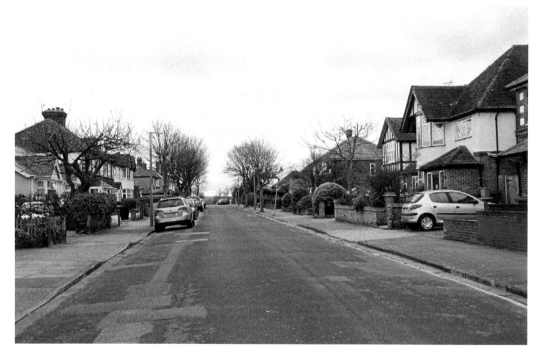

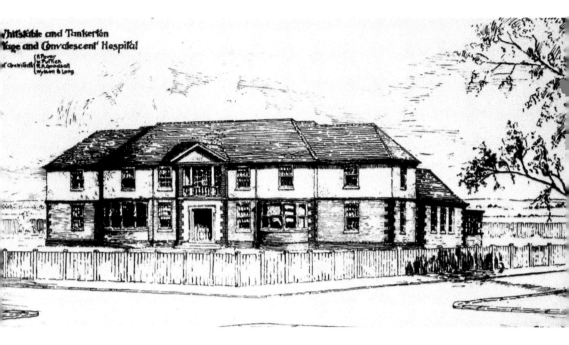

Whitstable and Tankerton Hospital

Robert Goodsell, a local architect, designed the Whitstable and Tankerton Hospital in the 1920s and it was built on the corner of Northwood Road and Pier Avenue. Today, it caters for patients requiring rehabilitation and has twenty-five beds. Robert Goodsell was also a keen historian and was the author of *Whitstable, Seasalter and Swalecliffe*, published in 1938.

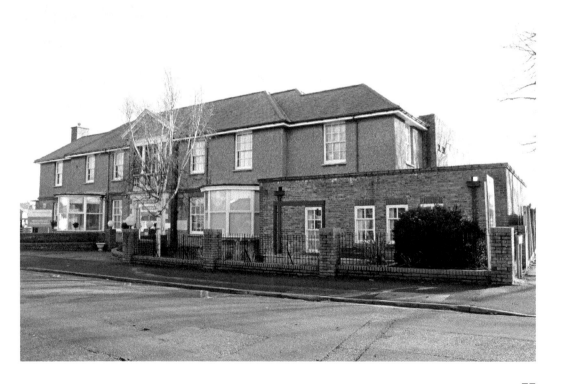

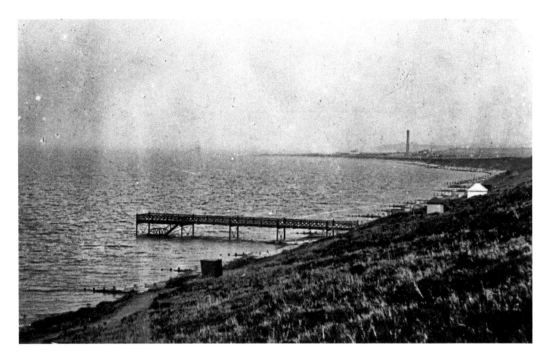

Tankerton Pier and Tankerton Beach

Opened to the public in 1894, the so-called 'Bedstead' was an attempt to make Tankerton more of a seaside resort. At only 125 feet long, it was a poor promenade and not serious enough to attract excursion steamers. In its honour, Station Road was renamed Pier Avenue in 1903, the proposed station in Ham Shades Lane never having materialised, but by 1913 it had deteriorated so much that it was removed by the council. The Swalecliffe brickworks' chimney is visible along the coast.

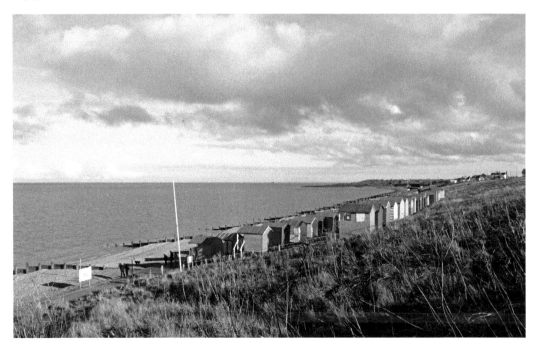

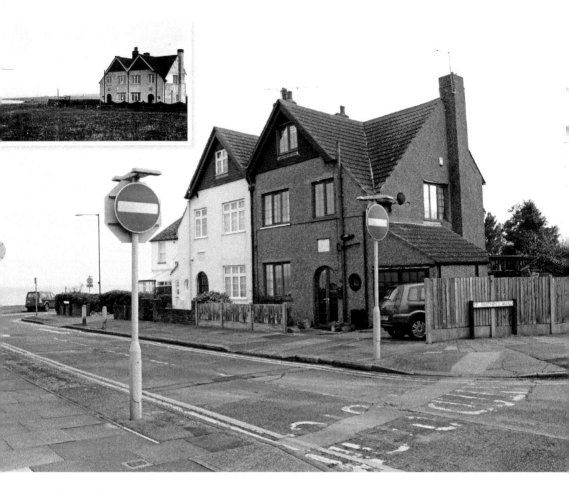

Priest and Sow Corner, Tankerton

Certainly not home to a public house of this name, this stretch of shore was possibly the location of a beacon. The Saxon *preost*, meaning 'priest', Anglo-Saxon *tan*, meaning 'fire', and Danish *how*, meaning 'boundary', could have given this area its name. Alternatively, it could have been named 'Pearson's Sough' after Charles Pearson, a local businessman. Today, it marks the far end of Tankerton and the beginning of Swalecliffe, although continuous development has long since linked the two.

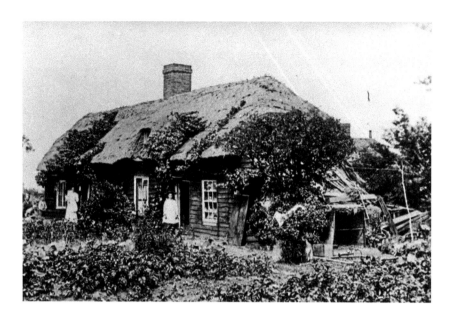

The Old Post Office and Herne Bay Road

The post office in Swalecliffe, *c.* 1890, was once part of a row of thatched cottages opposite Swalecliffe Court Drive. Swalecliffe is thought to come from the Old English word *swalwe*, meaning 'swallow', and *clif*, meaning 'hill-slope'. It is featured in the Domesday Book as Soaneclive, with eight cottagers recorded as living there. This grew to eleven houses in the sixteenth century and, when the church was rebuilt in 1875, the population was recorded at 167.

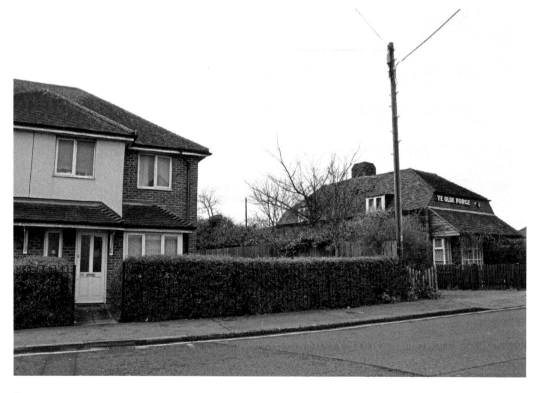

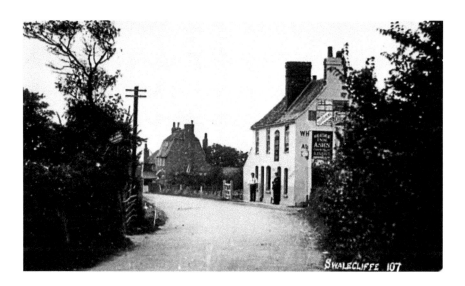

The Wheatsheaf, Swalecliffe

One of three pubs in Swalecliffe (the others being the Fan and the Plough), the Wheatsheaf Inn was demolished and moved back from its roadside position, and now has its car park to the front. The buildings further down the road in the old image are the Fan (no longer open) and the old post office in one of its earlier locations.

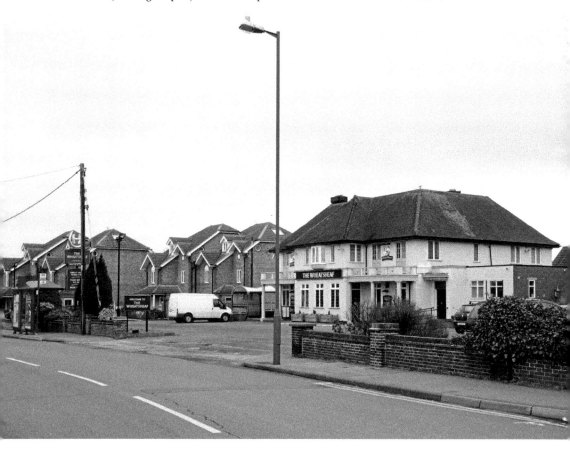

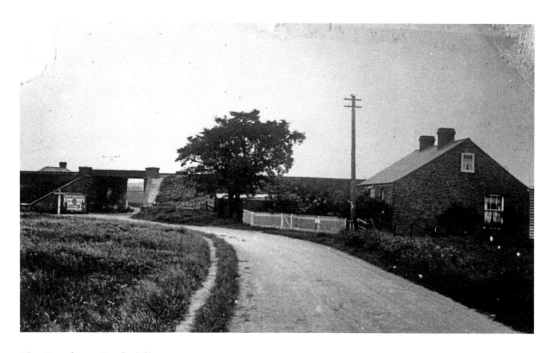

The Broadway, Swalecliffe

This early view of the junction of Herne Bay Road and Chestfield Road dates from around 1900. The London Chatham & Dover Railway route to Thanet clearly passes by on the embankment, but Swalecliffe Halt will not be built for another thirty years. The cottage to the right became a doctor's surgery but has since been demolished.

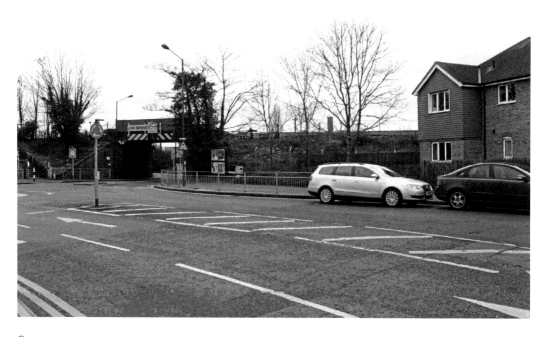

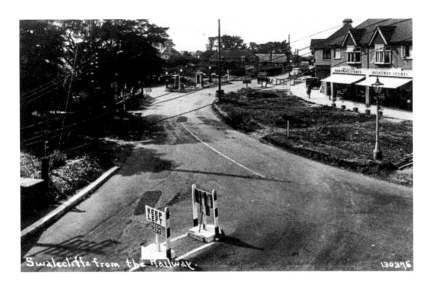

Swalecliffe From the Railway

A station known as Swalecliffe Halt was opened here on 6 July 1930, later becoming Chestfield and Swalecliffe Halt, then just Chestfield, and now Chestfield and Swalecliffe. Facilities consisted of concrete platforms (later replaced with wooden planks), a timber ticket office and timber shelters on each side. The view from the railway shows the parade of shops on the Broadway, which now houses the much relocated Swalecliffe post office.

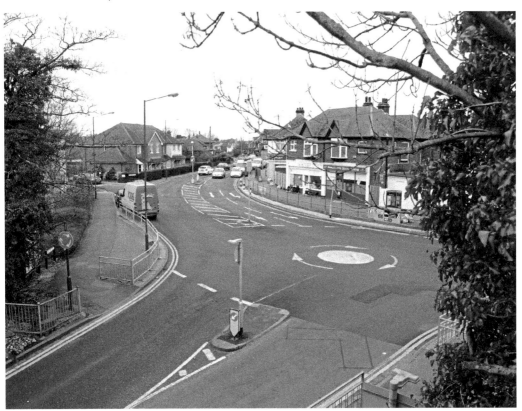

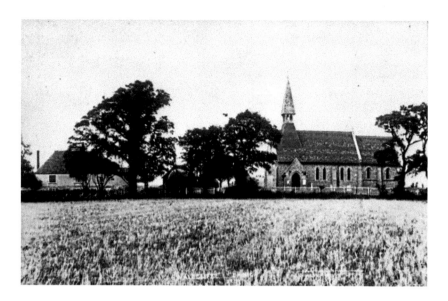

St John the Baptist Church, Swalecliffe
Registers at the St John the Baptist church date from 1558, but this church was built in 1875, in place of an earlier thirteenth-century building. It cost £1,410 and was known as the 'Church on the Seashore'. The fields were part of Swalecliffe Court Farm, later developed into a housing estate. The church has a pulpit, described as a 'monster of a thing', and a stained-glass window depicting a soldier who died in the First World War.

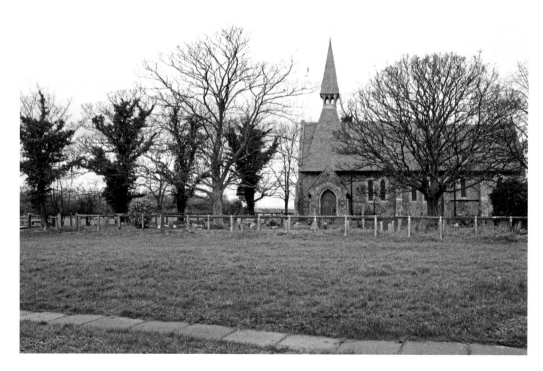

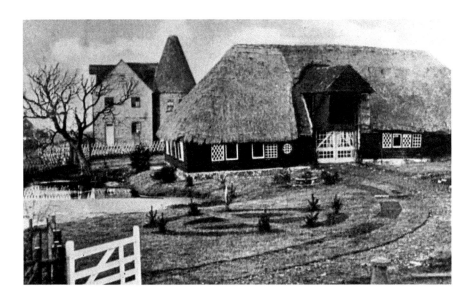

The Oast House and Barn, Chestfield

When George Reeves built the new village of Chestfield, he wanted his Tudor-style houses to be as authentic as possible and, so the story goes, banned his workers from using a spirit level. The resulting houses are undoubtedly charming, surrounding, as they do, these much older buildings. The barn is fourteenth century and the twin round kiln oast house is believed to date from around 1880.

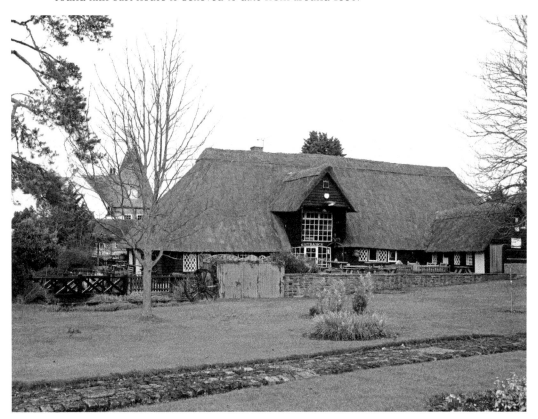

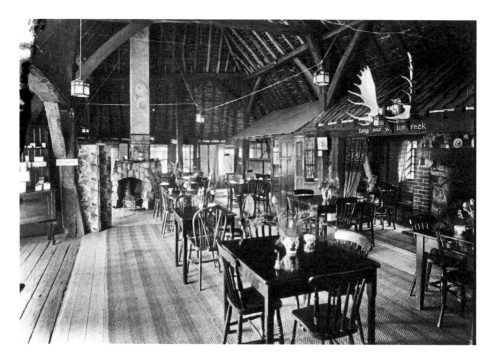

Chestfield Barn

The building, originally the barn for the Balsar Street Farm, where the Balsar family farmed for several centuries, is thought to date from 1343. By the eighteenth century, the farm had been incorporated with the manor, and in 1920 George Reeves purchased the Chestfield estate and planned a new village. The barn, which spent some time as a tea room before becoming a restaurant in the 1970s, is now a pub and restaurant.

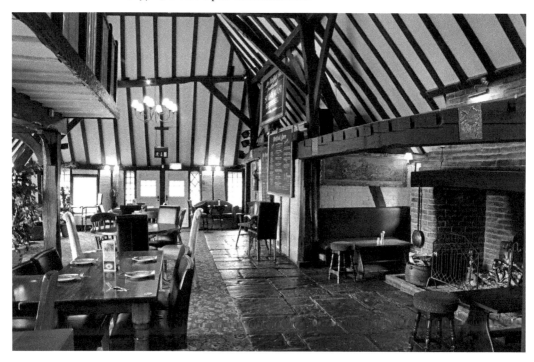

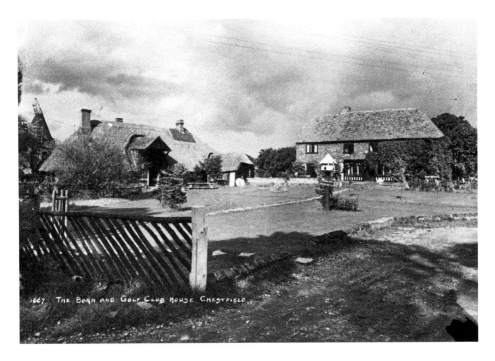

Chestfield Golf Club

The golf club, reputed to have the oldest clubhouse in the country, was opened on 5 May 1924. George Reeves had purchased 700 acres of farmland and built the course, originally locating the clubhouse in the fourteenth-century barn and later moving it to the dower house (the right-hand building). Five bombs fell on the eleventh hole in the Second World War, and sheep were grazed on the course to save it from being ploughed up.

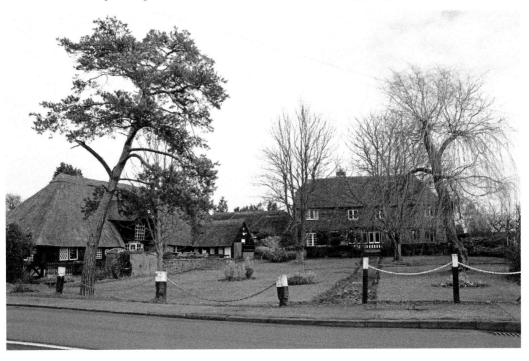

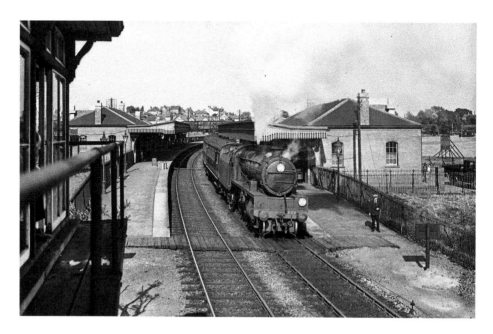

Whitstable Main Line Station

The main line station was first built in Clifton Road, approximately where it turns into Portway, when the main line came to Whitstable in 1860. An embankment was then constructed, and a bridge installed over Oxford Street, before the station was moved to Belmont Road, where there is now a caravan centre. The line was extended to Herne Bay in 1861 after the resolution of a dispute with the Canterbury & Whitstable Railway concerning bridging arrangements where the two lines crossed.

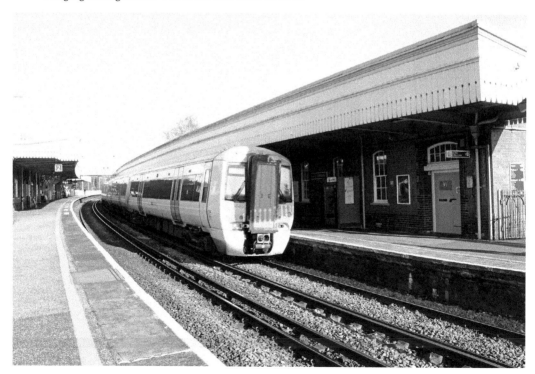

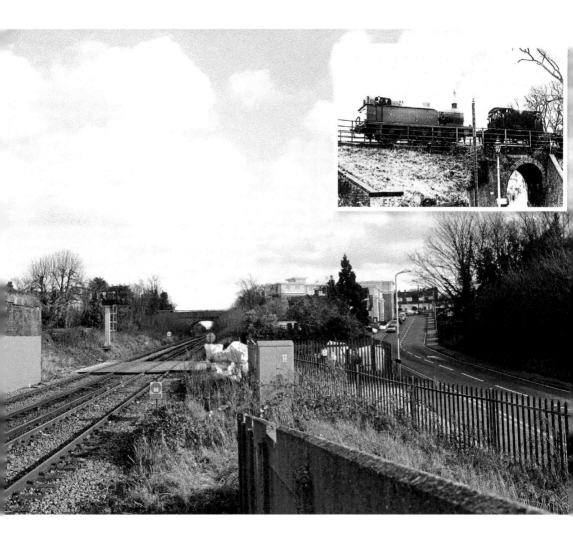

Bridge Approach

The bridge was built in the late 1820s for the Canterbury & Whitstable Railway and was situated at the bottom of Bridge Approach. It was demolished surreptitiously in 1969 by the district council, presumably because its notorious blind spot presented a hazard to the increasing volume of traffic on the roads. The council knew the move would be unpopular, as some claimed it was the oldest railway bridge in the world.

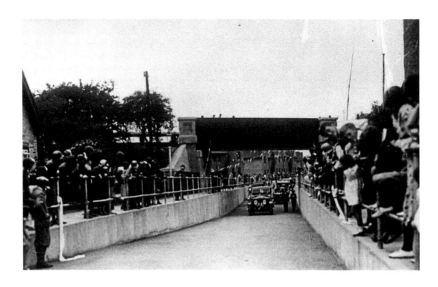

Teynham Road

Previously, the Canterbury & Whitstable Railway passed through here via an embankment edged with railings, with a stop called Tankerton Halt nearby. Before the Teynham Road subway (seen above) was opened in 1935, there was no access at this point through to Clare Road or Castle Road from Whitstable. The houses visible under the bridge had been constructed in the 1920s. The bridge was removed in the 1970s and recent attempts to have it reinstated have been unsuccessful.

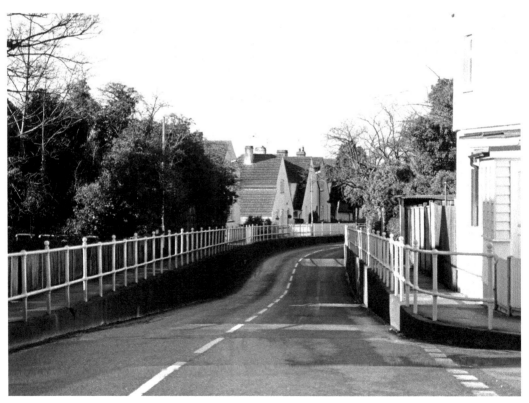

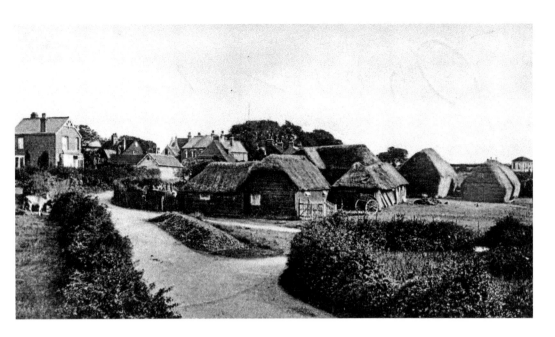

Church Street

This area, once Smeeds Farm, was named after James Smeed, who owned the land in 1863. It had previously been called Church Street Farm and, even earlier, Barnfield. Part of the land had been sold in 1824 to make way for the railway line from Canterbury, and the Crab & Winkle cycle route runs to the west of this area. The tall building behind the thatched barns was Ivy House, which has since been demolished and redeveloped as Ivy House Road.

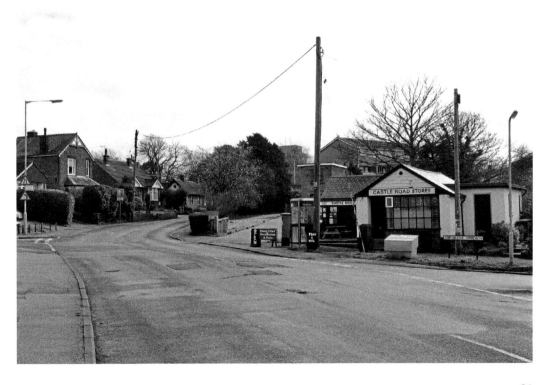

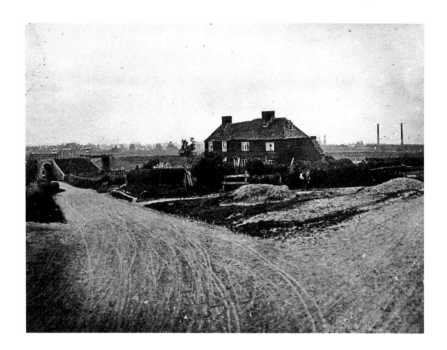

Church Street and Bridge Approach

The Butts Field Cottages in Church Street were at the junction of Bridge Approach (then called Church Road), shown here around 1880. Butts Field was so called because, at the time of Agincourt, it was compulsory for the men of the town to practice archery. A butt is a sawn piece of wood placed on its end as a target. In 2012, the Art Deco-style Carlton Court development was completed, replacing what had been for many years a derelict garage and unused site.

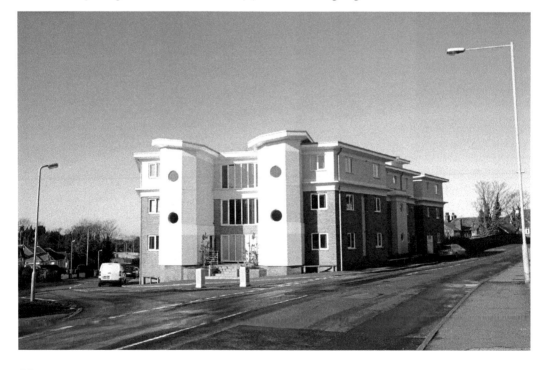

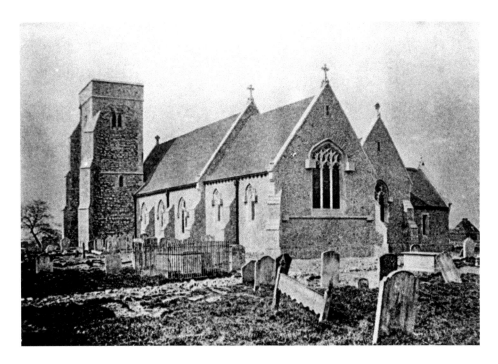

All Saints' Church

A church has stood on this site for at least 800 years and the nave is probably thirteenth century, constructed of flint from the local beach. The registers date from 1556 and part of the early settlement of Whitstable was centred on this area. In 1876, the walls were rebuilt on new foundations, and the south aisle was added in 1962. On 15 January 1944, a V2 rocket fell, damaging gravestones and the west window, as well as nearby cottages.

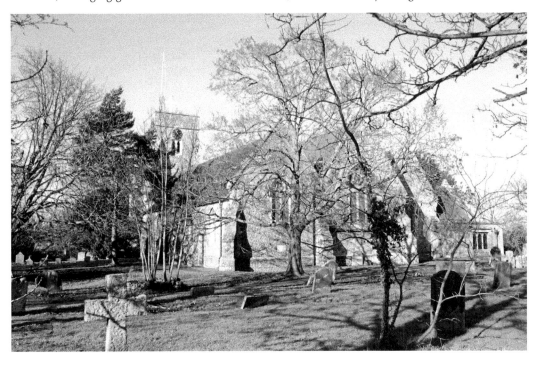

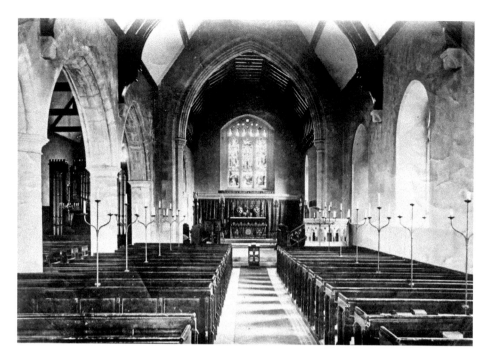

All Saints' Interior

Earliest surviving records show that Walter de Albiniaco was rector from 1257–87. The pulpit was given by Revd Henry Maugham in 1892 in memory of his first wife, and the lectern was fashioned in 1876 from timbers from the original nave roof. The Norman font has an unusual Tudor cover, with eight sides displaying coats of arms from the period. A consistory court decision in 1983 allowed pews to be replaced with chairs and the addition of a central, movable altar.

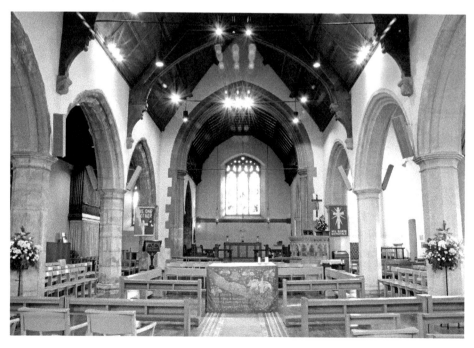

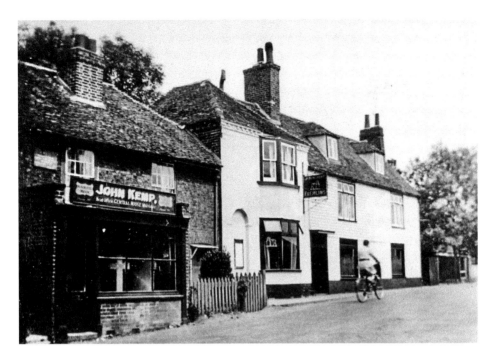

The Monument, Church Street

The building now housing The Monument pub was originally built as two dwellings. The left-hand side has a cellar and was probably a pub from the 1730s. The right-hand side may have been the blacksmith's house for the old forge, which was opposite. The forge, thought to be the oldest building in Whitstable, fell down in the 1930s. The Monument, however, is still going strong as a vibrant pub, restaurant and sports bar.

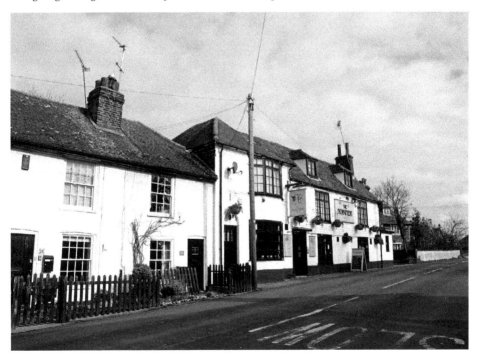